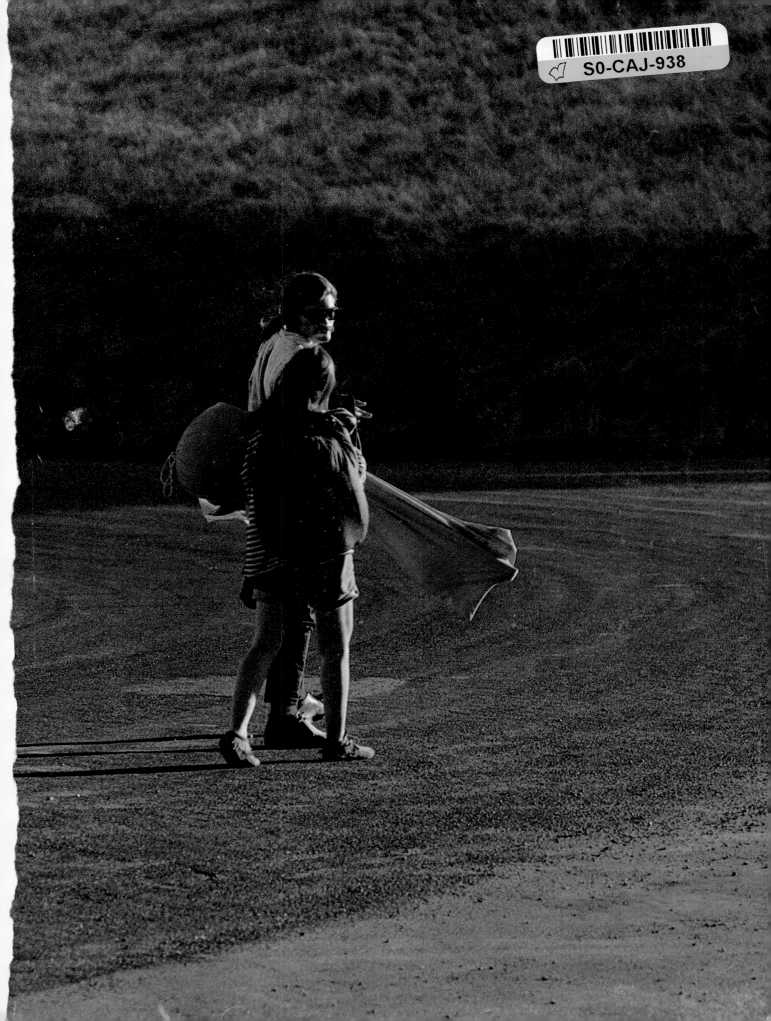

AQUARIAN ODYSSEY

A PHOTOGRAPHIC TRIP INTO THE SIXTIES
BY DON SNYDER

DESIGNED BY PHILIP SYKES

LIVERIGHT · NEW YORK

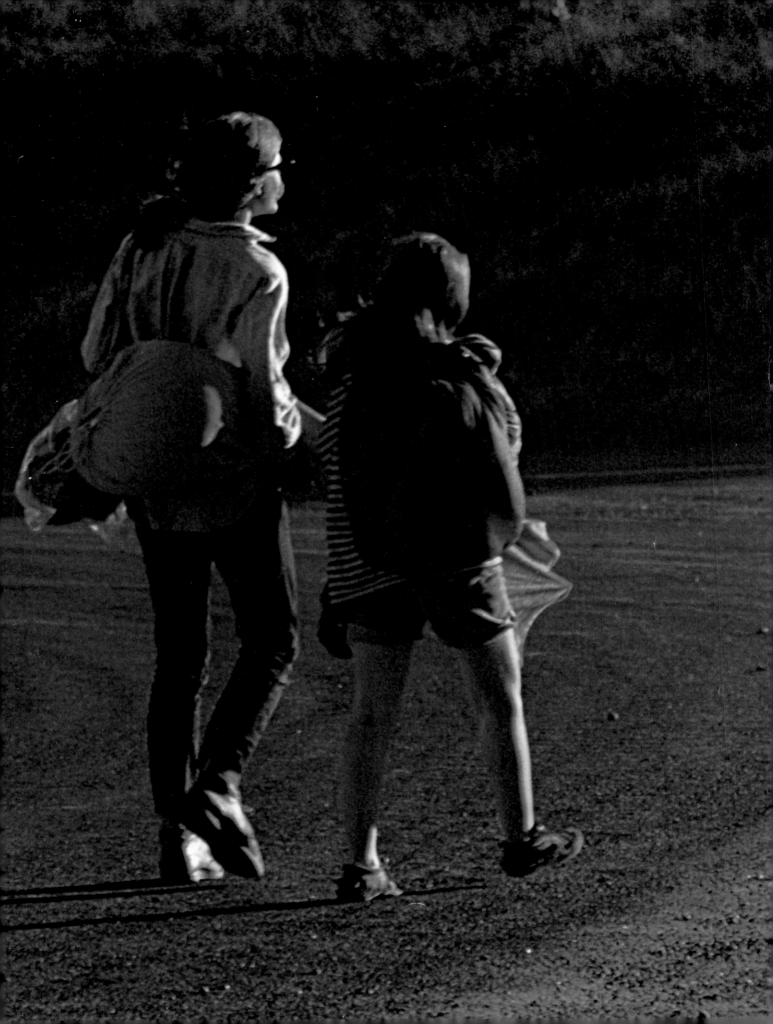

First published 1979, in the United States of America by Live-
right Publishing Corporation.

Published simultaneously in Canada by George J. McLeod Limited,
Toronto. Printed in United States of America.

All Rights Reserved

First Edition

All rights reserved under International and Pan-American Copyright Conven-
tions. Printed and bound by Dai Nippon Printing Co., Ltd., Tokyo, Japan

ISBN 0 87140 639 X cloth edition

ISBN 0 87140 126 6 paper edition

1 2 3 4 5 6 7 8 9 0

To our people and that time
To the mind magicians
Who made life a play
Upon a play, upon a play

And to the memories of
Irene Harris, photographer, 1943–1975
Angus MacLise, poet and musician, 1939–1979
Ray Brock, 1928–1979

I see all the overseers in the cloudy aeons
stretching away without pause—Angus MacLise

From TING-PA, Kathmandu, Nepal

The star is rising
 with great great power
through the vaults
 of carefree holocaust space
 I reach down
 into the incredible dim staircase
& out into the everywhere—electricity of space
 —surrendered as you are in dreams—
 We will speak no more
 of mysterious empires to be restored
 cryptic utterances of forlorn
 oracles have overwhelmed us
 —still
 I walk past
 the courts, the temples
belonging to the Masters
 of the Hill
 …my life
rests solidly on this casual assumption.
 Waiting
 on the side of the hill
 in starlit darkness; arms up
 & stiff
 in attitude of greeting
 towards the hill-top; eyes
 fixed and starting out; sweat
 shining on his face—
 standing enrapt before god;
 ….the ground where
I lay spoke the signature divine

 —so caress the heel
of the divine messenger as he leaves
overblowing on the flute of journey
 NO ONE
 in ecstasy at the borders
 Stars piercing
 delicate
 blindness of the Meadow
 Rock glistening
 on me, thinking
 burned out, I was
 w/o allies in that region forever
The Text is lost
 as a
burst of light appears behind us
 and whistling through
 the blood I dream of
the great and forgotten doctrine
 The Solar Angel
 in her storms, throwing
 over the face of
the cliff, rapid me
 messages
 blossoming in the Void.
 I knew it
was a hitchhiker's godlike fantasy
 —tw ing in the wind—
Light breaks
 the possibilities are endless.
I am not permitted to say anymore

 —Angus MacLise

Excerpts from THE CLOUD DOCTRINE,
Dreamweapon Press, Kathmandu, Nepal

travelin' man travelin' man
lay me down a line
if I could sell my travelin' song
I'd be travelin' all the time
—Therese Thebet

For many of us the Sixties was a turbulent period of complex revolutions, cultural upheaval, mind-expanding perceptions, internal liberation, and radical ideas. Some of these newly introduced concepts have passed over into mainstream American culture, though the peculiar ambiance of the time seems to be gone. Many of us believed it was the dawning of a new and better age. Some of us saw the revolution as political; others sought a more fundamental change, a spiritual and psychic transformation which would lead the alienated spirit of man back to a more wholesome reality, to the ever unfolding, the "eternal Now." It was with the latter in mind that Dr. Timothy Leary made the following comment on the psychedelic exploration he began at Harvard:

> I ate seven of the so-called "sacred mushrooms." I was whirled through an experience which could be described in many extravagant metaphors but which was above all and without question the deepest religious experience of my life.... Since my illumination of August 1960, I have devoted all of my energies to try and understand the revelatory potentialities of the human nervous system and to make these insights available to others.

The search for an internal illumination through drugs and mysticism violated more than the superficial mysticism of American society, as Charles L. Mee wrote in the spring 1970 issue of *Horizon* magazine:

> Are these kids mad? Yes. Or, if not mad, they are at least uncomfortable with the traditions they have inherited, and they are feverishly exploring all those men and ideas that their elders ignored or passed over lightly in their educations: the mystics, the madmen, the antira-

tionalists and the seers, demonology and shamanism, astrology and witchcraft. They are in flight from reason, as the Enlightenment understood reason; they are intent upon finding, or making a new tradition.

This is a somewhat academic appraisal of what I think was an essentially antiacademic movement. As Mee pointed out, the psychedelic era was not a period of logic and analysis for the hippies, heads, and freaks who created it. It was a period of sensuality, intuitivism, and emotional immediacy. "Celebrate sensation" was a catchword of the time. "Do your own thing" became the ethic.

The media quickly coopted the movement and made it out to be a completely new and unforeseen phenomenon. However, it was not without parallels in Western history. In an article on the counter-culture illustrated with my photographs which appeared in the spring 1968 issue of *Horizon* magazine, Joseph H. Thorndike noted:

> For Arnold Toynbee the hippies are reminiscent of the early Christians; for J. H. Plumb, of the medieval utopian groups like the Ranters and the Brethren of the Free Spirit. The hippies themselves feel akin to the American Indians and, equally, to the mystics of India…. Our readers can hardly fail to be struck by another resemblance—that between the "Flower People" of San Francisco and the "Flower People" of Renaissance Florence who appear in Sandro Botticelli's "Primavera"… the resemblance between Snyder's hippies and Botticelli's mythic deities is perhaps not entirely a visual accident.

If the hippies reminded these historians of so many different groups in so many different eras, it should not be so surprising. The search for new traditions, for new ways of thinking and living, have led us from William Blake to Zen, from Martin Luther to the Kabbalah. We were captivated by the possibility of a culturally and spiritually integrated world-view in which diverse races and mythologies might be threaded into one comprehensive tapestry. Many experimented with anything that might lead us to new truths: music, drugs, meditation, sorcery….

Rock 'n' roll, the music power of the Sixties, quickly united the two themes of spirituality and politics. The combination of its dynamic message with the audio-technological development in expensive stereo hi-fi systems became dynamite, a package easily accessible and widely distributed. Rock music as a pop art media loomed as the most important means for expressing and disseminating the ideas and feelings of the times. Rock communicated its "revolutionary" spiritual and political messages to people of the most diverse ethnic and economic backgrounds, and helped to bring together unexpected coalitions at the peace marches and civil rights demonstrations of cross-sections of Americans who had hitherto been indifferent or even hostile to each other and even to the causes they now espoused. Rock itself was naturally syncretic; it drew from, combined, and transformed older genres like folk, blues, country-and-western, Motown, etc. West Coast rock, emanating originally from the Fillmore and the Avalon, by groups such as the Grateful Dead, Janis Joplin, chanteuse for Big Brother and the Holding Company, and the Jefferson Airplane seemed primarily concerned with conveying the nature of the social-political situation and of the psychedelic experience. East Coast music, especially by the Velvet Underground in New York City's East Village, was shaped by and told of life in the urban ghetto, and tended more toward the cynical or pessimistic. Bob Dylan was made the lyricist of

the Sixties youth with Joan Baez his folk-heroine counterpart. Along with other singers and musicians their voices and rhythms could be heard from mountain to mountain across the country.

Part of the search for a new tradition involved experimenting in "alternative lifestyles." In the East, in places like the Berkshire Mountains in Massachusetts people usually lived in a spread-out community rather than in one house. As members of a financially independent counter-culture, they often worked for people in the surrounding area as carpenters, gardeners, painters, etc., choosing simpler ways of life closer to nature.

On the West Coast, people lived under one roof. Large groups would often get together to buy a ranch, build a house, farm the land, or work in cottage industries and would, as a group, attempt self-sufficiency. But almost everywhere people turned to "tribal" concepts of child rearing. Moral guidance and physical care were often considered the responsibility of the whole community rather than the responsibility of the biological, or nuclear family alone.

On the other side of the coin were Ken Kesey (author of *One Flew Over the Cuckoo's Nest*) and the Merry Pranksters. They traveled the country in a bus, experimenting with what might be termed the proselytizing "psychedelic Dadaism."

In urban areas like Haight-Ashbury in San Francisco and Greenwich Village in New York City, there was a continual influx of "flower children," many of whom were still in their teens. They would often arrive penniless with only the notion that something vital was going on and that this was the place to be. Groups like the Diggers and the Family Dog provided free food and sometimes "crash pads" for them.

And no matter what else, drugs were hawked right on the streets. One of the more prominent centers of original thinking and sources of influence during this period was the Castalia Foundation at Millbrook, N.Y., the site of Timothy Leary's psychedelic community experiment, which occupied a sixty-four room mansion (the "Big House") on a 3,000 acre estate. Some residents and visitors at the chateau, as the media often referred to it, chose to camp out in teepees or tents. In the beginning children lived in a house by themselves, and were instructed that bedtime was when they were too sleepy to stay awake.

In that era of living fairy tales some flower children, like Snow White, forgot that apples are sometimes poisoned. They tried everything and followed anyone. In the wake of the real leaders came false prophets with Messianic delusions, who preyed on the minds of the more naive youth. The threat of the draft and the disillusioning political situation of the time added to their problems. All this injected a salty note of pessimism and harshness into the sweetness of the time. And though the optimism of the early Sixties faded along with the feeling that the corruption of the world around would become diminished, the fact remains that the psychedelic period of the Sixties ignited the fire of a cultural movement, with implications for the future that were unforeseeable. It provided dreams that enabled many to discover the possibility of the miraculous. For those of us who lived through its enchantments, it was a mad, magic time when both innocence and decadence danced increasingly to the same music.

By 1960, I had become aware of a body of literature on the subject of alternate states of consciousness and the

mystic voyage of self-discovery and was inspired by the works of Kafka, Hesse, Ouspensky, and Gurdjieff to explore my own relationship between myself and art. I first took peyote in 1964 with a group of friends. At the time I didn't know what the word "trip" meant. I was asked by a friend to make an ordinary passport picture for him. While tripping, I was quite convinced that I was cold sober, so I went into the darkroom and spent hours printing boxes of 11″ x 14″ blow-ups of his nose, his eyes, his forehead, and his beard, assuming that I was working to scale. Later, I realized that the psychedelic had completely altered my sense of proportion. But I handed him a box of gigantic hallucinatory images anyway.

In 1965 I began to expand my photographic experiments by painting abstract organic shapes on glass slides, some of which I collaged with photographs, and projected them in my studio for friends. An electrician friend helped me develop a dissolve system which allowed me to control the sequences and slowly fade the slides in and out of each other and superimpose them in a quasi-cinematic way, inducing a mild trancelike state. I combined and accompanied these projections with tapes of experimental music by friends—La Monte Young, Angus MacLise, Mike Sahl, and others. Angus's Arabian flutes and drums mixed with and by electronic sound synthesizers seemed to create an environment of mythic forms which emerged from the dissolving projections. It was the beginning of my experiments with art and technology which later became labeled and promoted as "psychedelic art."

I participated in the first expanded cinema festival in New York organized by Jonas Mekas and John Brockman, which was in actuality one of the first mixed media, multi-media public performances—theater that combined practically all art media from dance to film, music to sculpture, and poetry to painting.

Dr. Ralph Metzner invited me to come to the Castalia Foundation at Millbrook, N.Y., so my multimedia/audiovisual techniques could be used to help illustrate Timothy Leary's experiments in consciousness expansion. Leary was working with the idea of using ancient myths and archetypes as a guide on the voyage of self-discovery, and he needed a theatrical environment which would more effectively communicate his concepts. When I arrived at Millbrook, I was greeted with the following message, which was posted on the door:

THIS HOUSE IS THE HEADQUARTERS OF A COMMUNITY WHICH HAS COMMITTED ITSELF TO THE PERFORMANCE OF CERTAIN CREATIVE ACTIVITIES: SOME CHOREOGRAPHED, SOME IMPROVISED. YOUR ENTRANCE INTO THIS COMMUNITY PLACES YOU IN THE MIDST OF AN ON-GOING DANCE.

Leary made effective use of my lumographs in his elaborate psychedelic slide presentations, in which a battery of projectors combined, superimposed, flickered, and faded the slides and which resulted in the first public performance at the New Theater in New York City, guided by Timothy Leary in 1965. Eventually I collaborated with Masters and Houston (authors of *The Varieties of Psychedelic Experience*) in creating an experimental programmed "environment" for their research into alternate states of consciousness.

This book undoubtedly reflects my early experience. I spent much of my youth in Coney Island in Brooklyn, where I became very familiar with the odd variety of gypsy vendors, street hustlers, and "freaks," people who derived their in-

come by performing for the millions of summer visitors. This resulted in an extensive series of documentary photographs that I called "The Inferno." It was those photographs that made me aware of the need to relate the background of a picture to its foreground in one sharply resolved all-inclusive snap: I wanted to include contextual information in my portraits, so that the image would be located in an identifiable time and place. But the normal or even semi–wide-angle lenses were inadequate for the optical perspective I was looking for. I hungered to include "the all and everything" of the moment—but it was not then technically feasible.

In 1962, after acquiring a prototype of the first SWC Hassalblad camera with its remarkable super–wide-angle lens, I began experimenting with its extended-view perspective. My involvement in the search for new ways of thinking and the free visual motif of the Sixties led me to experiment with long exposures and super-wide perspective, using small apertures to exploit the extreme depth potential of the 38mm Biogon lens. Considering its size and weight, the Hassalblad seemed as portable as any 35mm camera, and had the definite advantage of a larger film format (2-1/4″ x 2-1/4″), which allowed for greater enlargements. Even though it was not as convenient for composing as a reflex camera, I still consider it a major optical gift to subjective photography.

It had been evident to me early on that I was at odds with the commonly accepted belief that professional photographers must remain completely objective. That didn't suit my needs, experience, or goals. I believed that photography was inherently an artistic medium. It did not seem plausible that I could detach myself from either the people or the environment I was photographing, even when I "post- created" in the darkroom by chemically altering the image.

Earlier, in the late 1950s, I had been employed as an assistant by the Alan Arbus studio, where I met Diane Arbus. I happened to see a batch of her early prints, which made a strong impression on me. At that time she was emphasizing the patterns of film grain in a kind of photographic pointilism. They were not fashion photographs, but rather portraits of the most ordinary people to whom she had somehow given an extraordinary quality. We became friends because we shared a feeling for the ways photography could be used to convey an artistic understanding and interpretation of the subject matter.

Diane Arbus once said something that reminded me of what it was all about: "Very often an event happens scattered…. One person is over there and another person is over here and they don't get together, unless you tell them to go there." I often encountered the same problem, realizing that optical manipulation and posing were an inherent virtue of my own photography. Other developments, including the use of drugs, affected our artistic perception. A number of artists felt that LSD was the inspiration of artistic perception and catalyst for their work, but I believed that increasing tecnhological capability exerted far more importance and influence. I could readily see the cross between traditional art and technological innovations, which provided the new tools for artistic expression in all media. LSD expanded our bag of tricks, but it did not and could not of itself provide artists with talent if it wasn't there to begin with.

The subjects that interested me, particularly during the Sixties, seemed to demand a treatment radically different from that of conventional photography. My equipment allowed me to photograph people in a very small room, or a large group anywhere, and still be close enough to be able to relate and communicate with them, and not be forced by

the inadequacy of my equipment to back off. Though I was aware that my approach might not be considered an acceptable method or technique for portraitures, I was nonetheless compensated by the results I achieved. Long exposures give an ultra special quality to color photographs. Through a visually intuitive process of multiple exposures I found that I could produce an image infused with extraordinary colorations on one frame of film with contours that were both soft and crisp at the same time. As a result, my portraits seemed to have a multidimensional roundness to them, complemented and balanced by the flattening out of the periphery field. These effects seemed to relate directly to the unconscious or dreamlike quality I perceived in my everyday life. I soon found that mixing many different and sometimes incongruous light sources, candles and strobe flashes and others, imparted at times a most scintillating and opulent character to the pictures.

In the 1950s I "rediscovered" the process in photography called "solarization"—meaning the partial reversal of a film or paper induced by a brief fogging exposure to light at a particular stage in developing. The graphic impact and strange dreamlike beauty of solarized images fascinated me. I was captivated by the many possible effects of different chemicals on the photographic image and discovered that these changes could often be partially reversed by solarization. I began to experiment with this "alchemical" technology and soon learned that Man Ray, that great artist and photographer of the 1930s, had also intimately explored solarization, especially in his portraiture.

Man Ray has described this effect, in another way: "the recognition of an image that has tragically survived an experience, recalling the event more or less clearly, like the undisturbed ashes of an object consumed in flames.... The creator dealing in human values allows the subconscious forces to filter through him colored by his own selectivity, which is universal human desire...."

I went from that to "lensless photography" and images made without a camera directly on photosensitized materials, which led me back again to Man Ray and Moholy Nagy. The photogram, "rayogram," etc., became the mainstays of my work, and led to the creation of the light-projection shows using slide impositions. Long before my own experiments Nagy had discovered the same effect: "Binding different space and time levels together...in photography usually appears as superimpositions...Superimposing of photographs, as frequently seen in motion picture dissolves, can be used as the space-time visual representational form of dreams.".

All of these influences came into play in the photographs of this book. I had hoped to include in this collection all the artistic and spiritual wayfarers of the period. But in spite of my grandiose intentions my thousands of transparencies and negatives were evidently only the tip of the iceberg, of which only a small portion are represented here. I soon felt compelled to photograph my friends, visitors, and people I met across the country—gurus, maharishis, and holy men; scientists, spiritualists, dealers, and Jesus-freak junkies; psychedelic cowboys and rabbinical visionaries, cosmological entrepreneurs and stockbrokers; video mechanics and electronic artists jacked into the amphitheatre of human evolution; a panorama of pretenders to the throne of enlightenment. My camera became a crystalline needle stitching myriad facets of space between people I have known. While most of the pictures need little or no explanation, a few have stories not explained in the captions.

THE GREAT GOLDEN MIRROR IN THE BIG HOUSE AT MILLBROOK was taken when the Big House was still buzzing with psychic energies. Coming down the stairs, I spotted Tim Leary vacuuming the floor, and, looking at his reflection in the mirror, realized that anyone and everyone who came through the front door had passed in front of that mirror. It had witnessed and reflected all the dramatis personae of the unfolding history of the psychedelic age. I cleaned, polished, and photographed it with the care it deserved. At the time, I didn't know that jazz musician Maynard Ferguson had planted the mirror in that supreme, knowing position. "Mirror, mirror on the wall, who's the most enlightened of them all?" it seemed to say.

TIMOTHY LEARY ON THE WHITE HORSE. Sudden and unusual occurrences were quite common in Millbrook. One Sunday afternoon, as I sat on the veranda, I was suddenly presented with a host of horses and riders, one of which was Tim as you see him. First he was riding a brown horse, then a white one. I don't remember if I requested the white one, but the Lone Ranger Leary and Silver came together to produce a psychedelic cowboy quite appropriate for those times.

MICHAEL HOLLINGSHEAD ON THE STEPS OF #5 HARVARD SQUARE. We had been ferrying Arthur Stoyer, producer of the Psychedelic Burlesque in New York City, around the country, trying to find, with the help of Providence, a cure for his crippling arthritis. Suddenly, we were in front of #5 Harvard Square in Cambridge, where, Michael told me, he had brought some mayonnaise jars of LSD to Dr. Timothy Leary years before. He then asked me to photograph him on those same steps that he walked up when he had first presented Tim with the most powerful psychedelic substance known to date, and which he felt had propelled Tim Leary into becoming the first guru of psychedelia.

BOBBY BEAUSOLEIL ON THE STEPS OF HIS HOUSE. This prophetic photo remains an enigma to me. It has become a controversial picture for those who are aware of the notoriety Bobby later acquired in his association with Charles Manson. At the time I made it, however, he was the lead guitarist in his rock band, The Magic Powerhouse of OZ. Bobby posed for me in front of his house where "Do What Thou Wilt" had already been painted on the door by someone unknown. But to me he had been simply a rock musician doing his thing in Haight-Ashbury.

JANIS JOPLIN. This picture of Janis and the original members of Big Brother and the Holding Company was taken in the backstage room of either the Fillmore or the Avalon, I can never recall which, before she attained stardom. Later on, after the performance, we talked and I offered to make a glamour portrait of her that would make her famous, if nothing else. I never did get to photograph her in that way, nor did she ultimately need it.

KUSAMA AND HER ENTOURAGE. Kusama was an artist from Japan, in tune with the times, and hell-bent on the publicity to prove it. Her performances, in which she strove for self-obliteration through simulated sexual orgies, were widely attended by curious New Yorkers. I became her friend, realizing that she was more than a casual 42nd Street sideshow, and that, like Yoko Ono, she was in the mainstream of Dadaist art.

WAVY GRAVY. I first met Hugh Romney of the Merry Pranksters at the Bitter End Cafe on MacDougal Street in

New York City. Later on, when I ran into the group again in California, they were calling themselves The Hog Farm and Hugh had changed his name to Wavy Gravy.

THE LIVING THEATRE'S PRODUCTION OF *PARADISE NOW.* I became so involved on the first night I saw it I decided not to take any photos. I participated while observing. But the next day I acquired a new type of film, just becoming available, Infra Red Ektachrome, which I fantasized would record body heat in crazy colors. The following night, I proceeded to freak out with it, searching out dim corners of the stage in order to superimpose image on image by multiple exposures, which I hoped would convey the intensity of the performance. To heighten the effects, I tried baking some of the exposed film in the oven for twenty minutes. Seeing these slides projected later in multimedia shows, one dissolving into another, made me feel that I had come close to expressing the vision that Julian Beck, Judith Malina, and the actors had shared with me.

CHOCOLATE GEORGE. There is something about the Hell's Angels which always invites a double-take. I felt that way when I heard the roar of their motorcycles on the Haight-Ashbury strip, and noticed the Angels stopping here and there, even stopping traffic at times to check out some new hippie arrival on the Haight; or interceding and trying to cool out a hassle that a hippie was having with the police. It seemed strange that icons of surly rebellion were acting as guardians of the naive and defenseless.

Later on, Emmet Grogan, one of my guides, told me that "Chocolate George," a Hell's Angel particularly respected by the Haight-Ashbury hippies for his good deeds, had been killed recently in an accident on the Haight. There would be a funeral, and afterwards a concert by Janis Joplin and the Grateful Dead was scheduled in Golden Gate Park. My wife Mikki and I rode in the car that was the unofficial honor column of hundreds of motorcycles and cars going to the cemetery. It was all quite elegant until they broke out the beer; then the funeral disintegrated into scattered fights with or between other motorcycle groups (such as the Nomads and Satan's Slaves) who had attended the funeral. At the rock concerts the Hell's Angels gave only an illusory protection to the flower children, who were continually harassed by the cops. However, their "protection" often degenerated into gratuitous acts of violence. I never did photograph Chocolate George lying in state at the funeral parlor. I had been told that the family would not look kindly upon that kind of intrusion, but I still think I was ill-advised, considering the splendor of his "Chicago-style" funeral, the countless flowers, wreaths, and swastikas.

By 1970 many of the communes like Morningstar seemed to disband, the energy was dispersed in many different directions. It was the time of the "big wash out." People were fleeing the flower era. It was the end of an age.

> It no longer mattered very much whether one person was able to walk on water without fear of drowning or not drowning besides or another be raised from that quality of sleep we misrepresent as death, for there was no longer anyone around to believe in such miracles that would allow them to happen, simply because of the climate of belief in miracles no longer existed.
>
> —Gerard Melanga

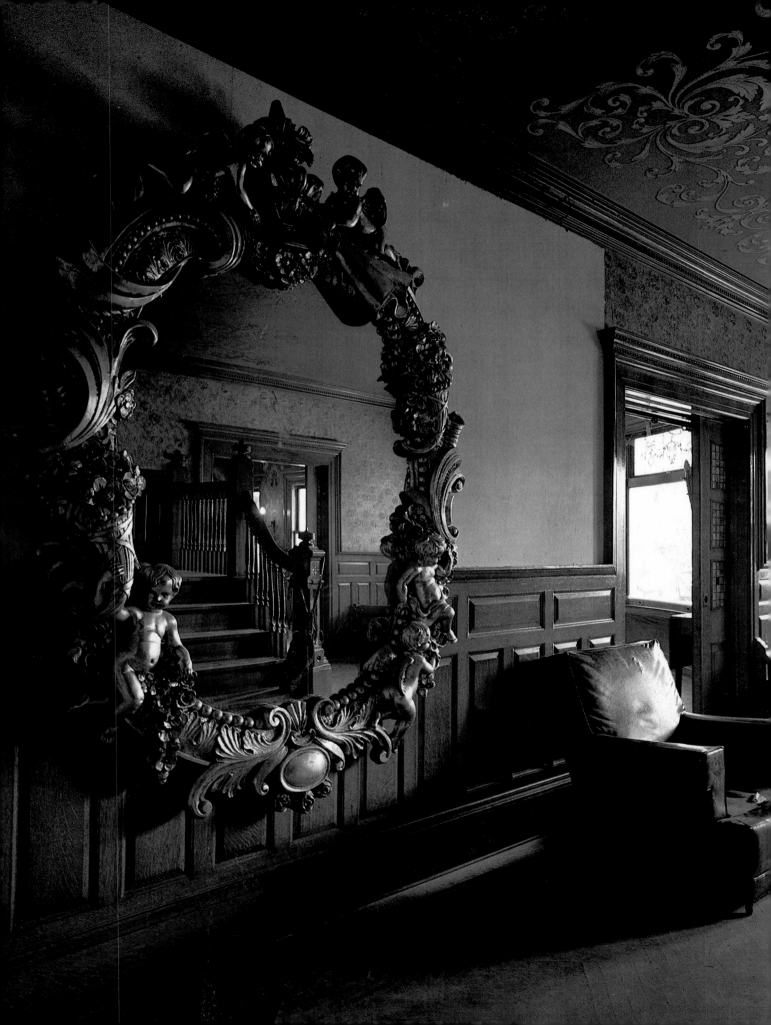

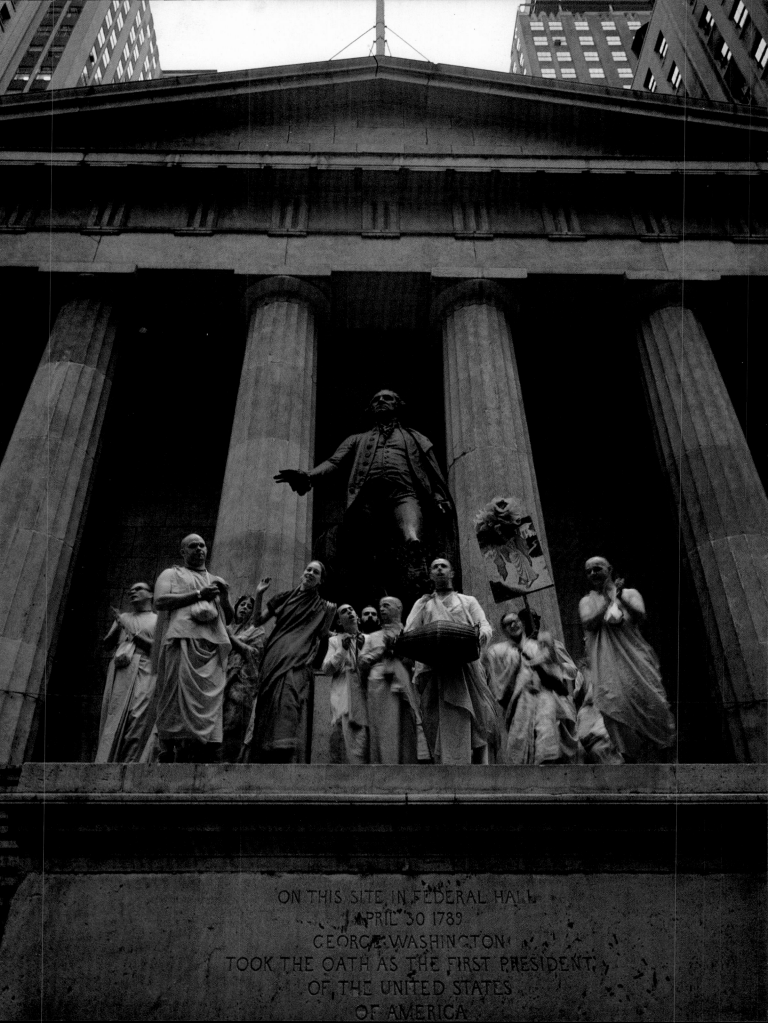

ON THIS SITE IN FEDERAL HALL
APRIL 30 1789
GEORGE WASHINGTON
TOOK THE OATH AS THE FIRST PRESIDENT
OF THE UNITED STATES
OF AMERICA

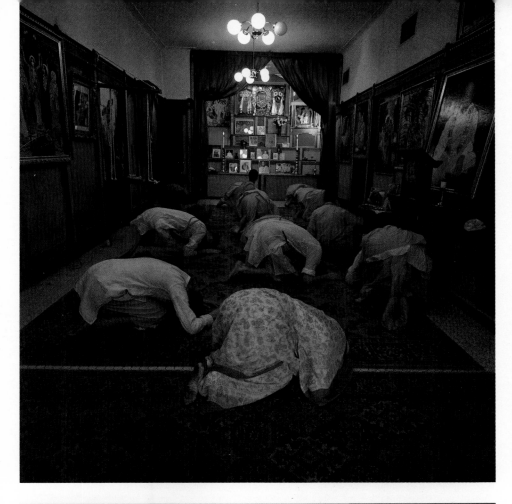

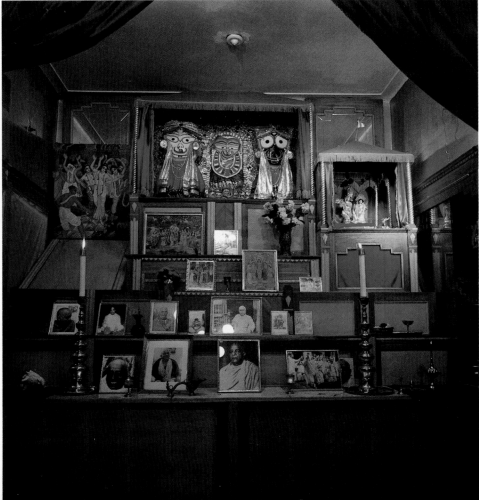

Krishnaites in New York City.
Opposite: devotees at the Federal
Plaza at dawn. Upper left:
devotees of Bakhtivedanta Swami
worshiping in a temple on the
Lower East Side. Lower left:
Krishna altar. Above: Proselytizing
on Wall Street.

PRECEDING PAGE. The great
golden mirror in the Big House,
Millbrook, New York.

Opposite: Esther, a tarot reader, in the John Muir National Forest in Northern California. Right: Baba Ram Das, formerly Dr. Richard Alpert, professor of psychology at Harvard, sequestered at his father's estate in New Hampshire, shortly after his conversion to Hinduism and return from India. Below: Baba Ram Das displays his new license plate. Below right: Spiritual graffiti.

OVERLEAF: Baba Ram Das making his first public appearance after his return from India, in New York City.
There are three stages in this journey that I have been on...and the third the yogi stage...each is contributing to the next. It's like the unfolding of a lotus flower.

SECOND OVERLEAF: Left: Barry Shapiro in the Berkshires, Massachusetts. Right: Barry Silverstein, a cook at a macrobiotic restaurant in New York City.

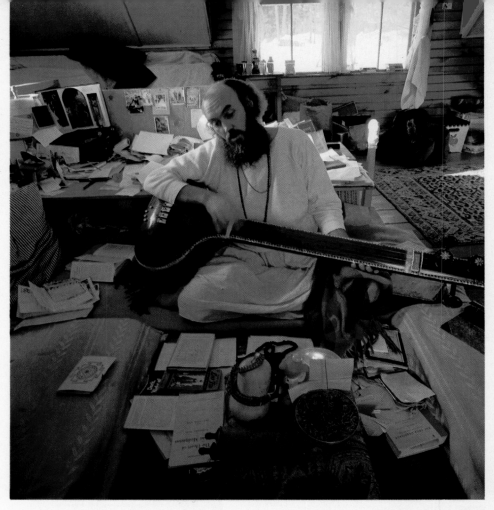

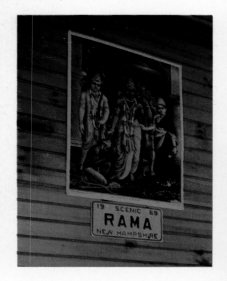

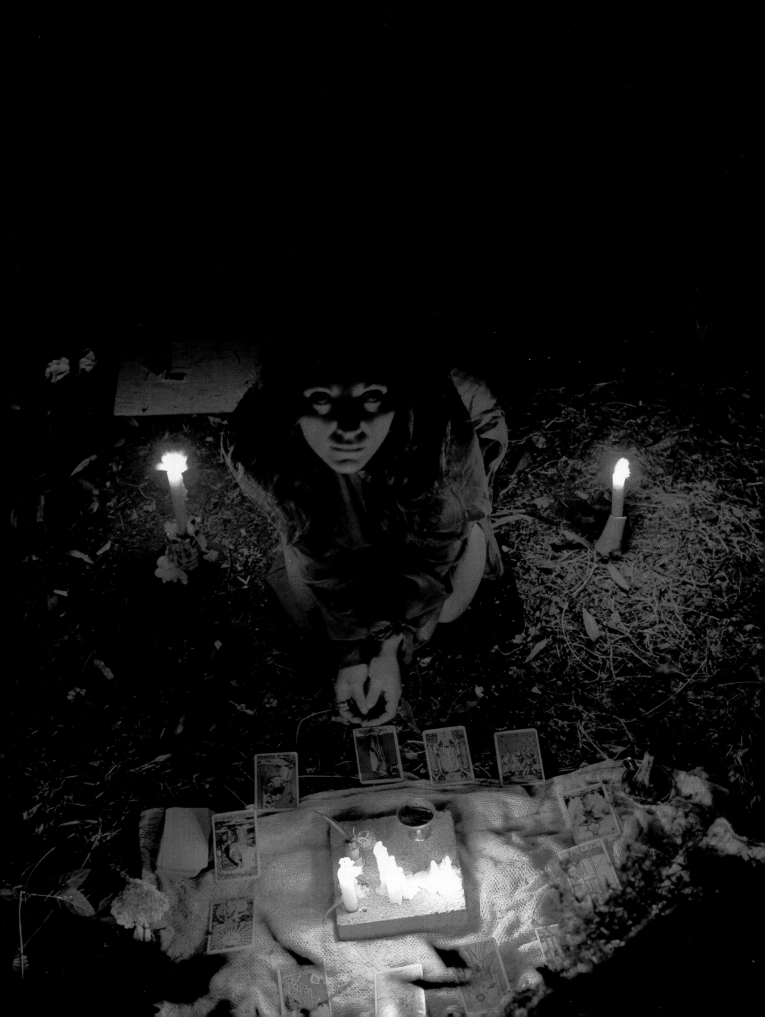

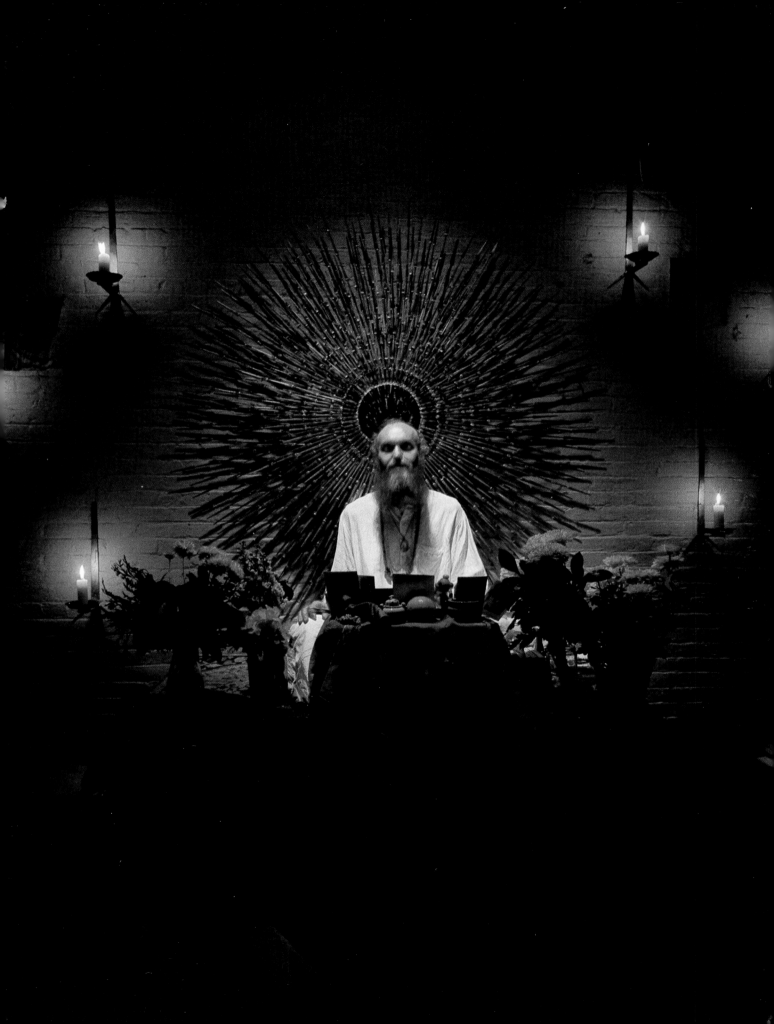

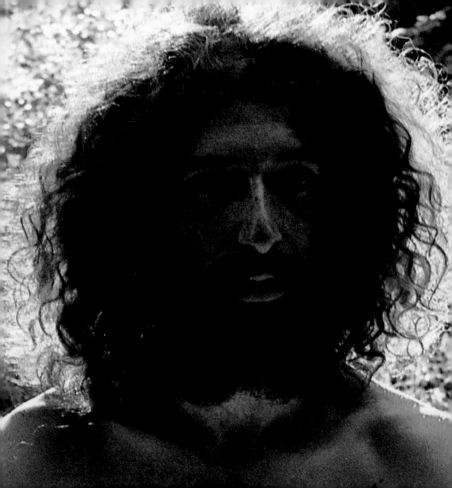

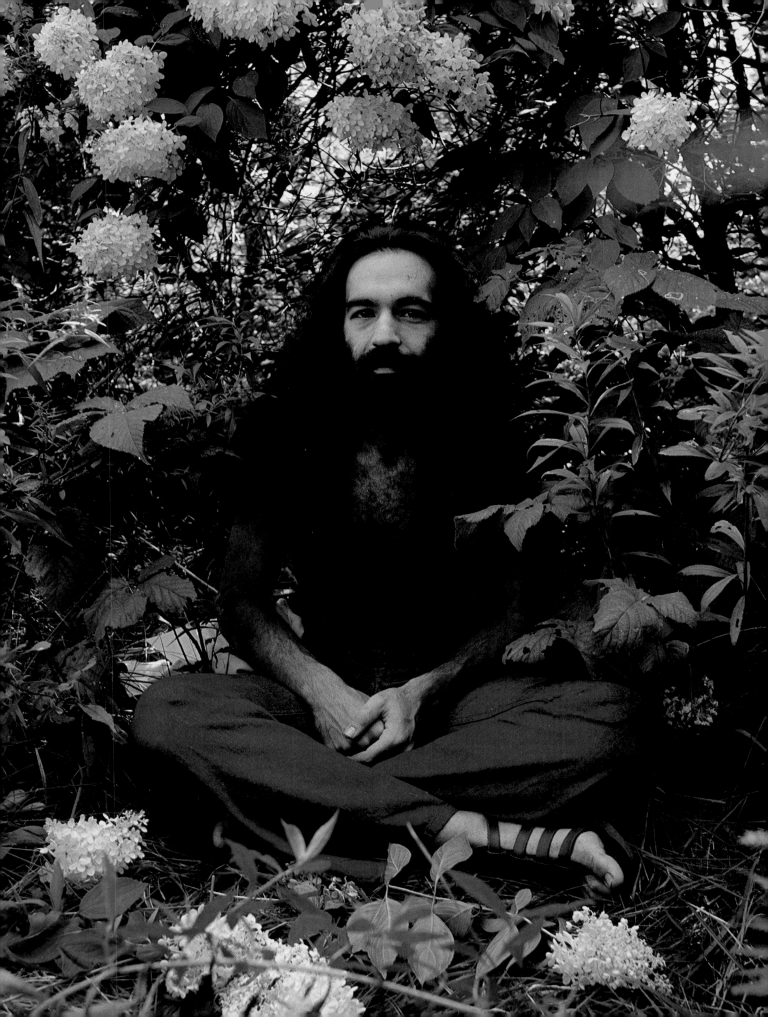

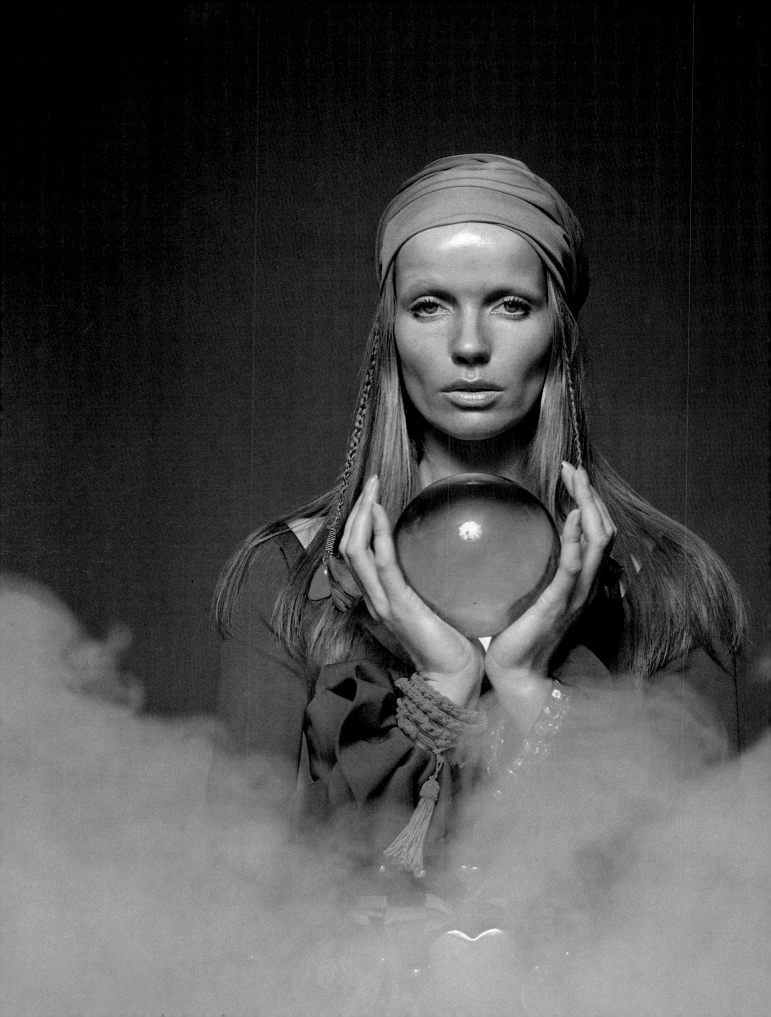

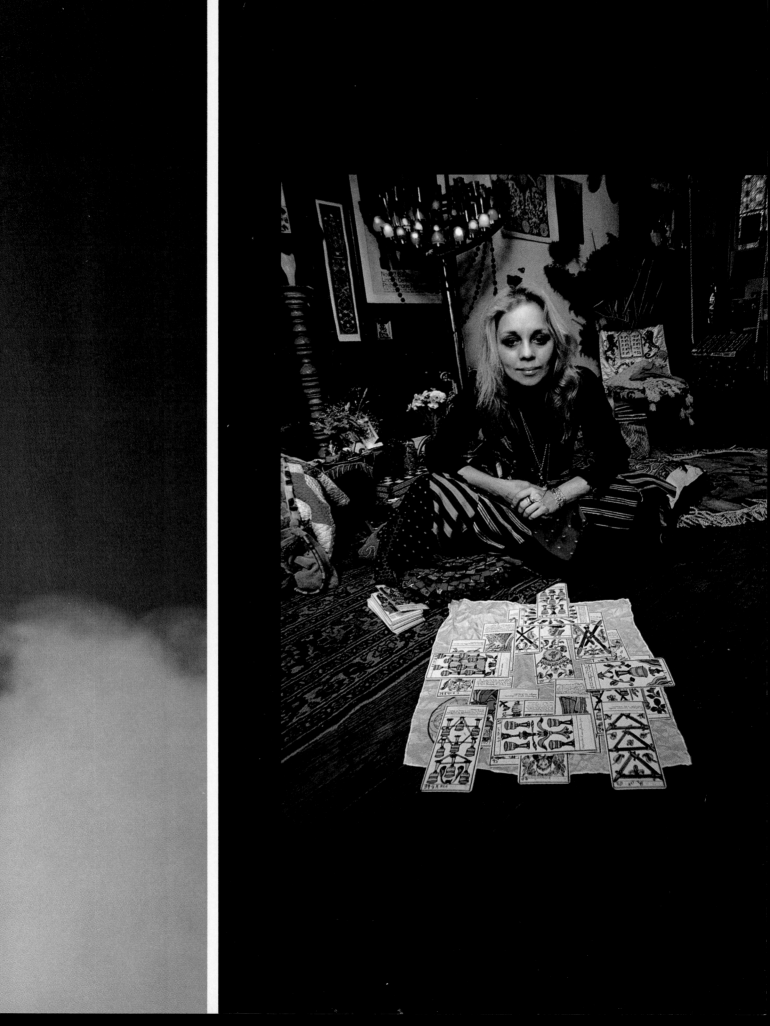

Right: The late Barbara St. John, astrologer, on the New Jersey shore.

PRECEDING PAGES. Left: Veroushka, modeling as a crystal-ball gazer, on an assignment for *McCall's* magazine. Right: Kasoundra Kasoundra, artist and high priestess of the Light, reading the sign of the times in her New York City studio.

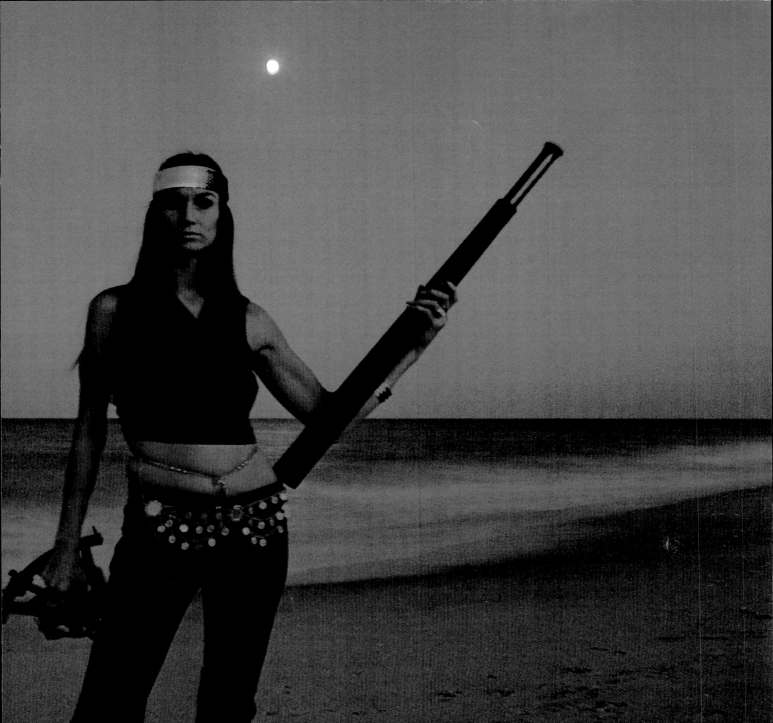

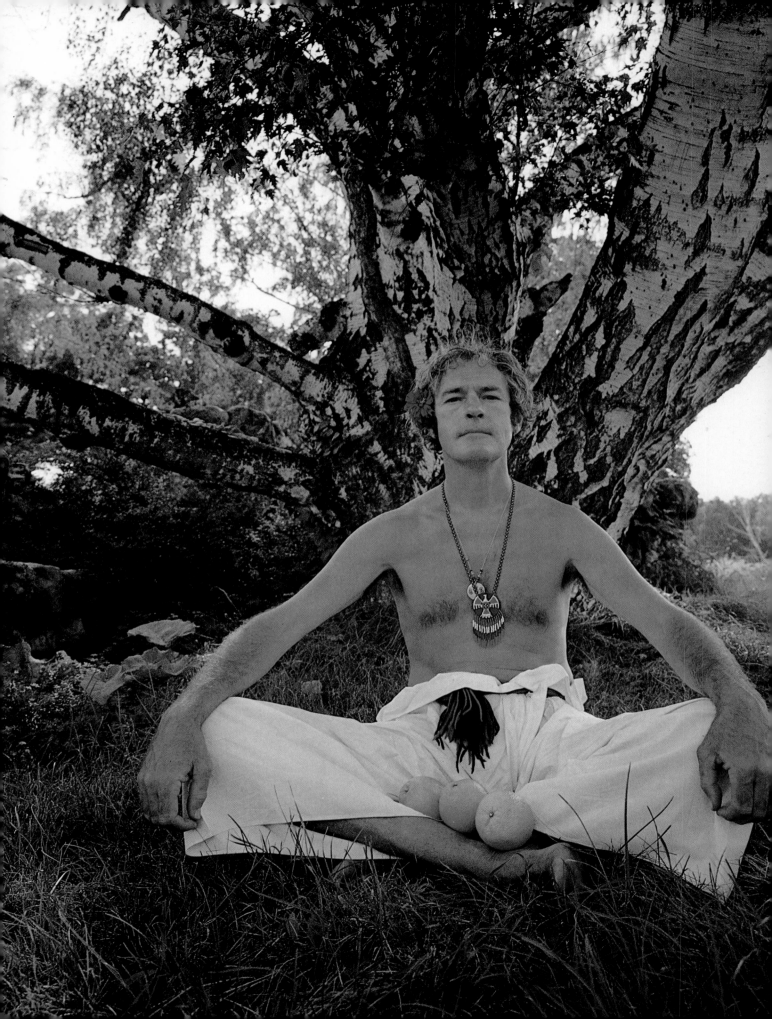

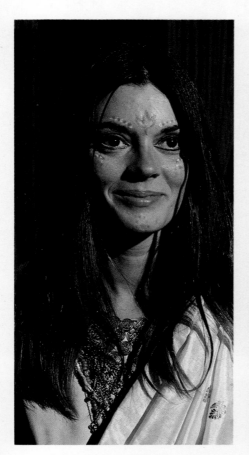

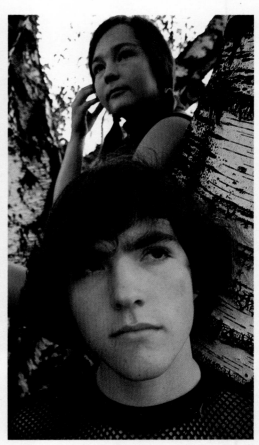

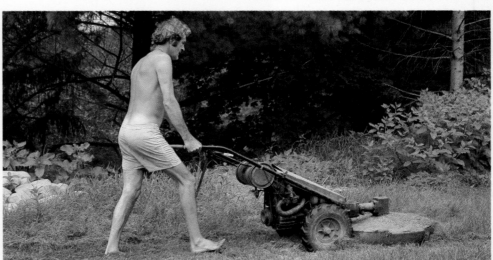

Opposite: Timothy Leary under the "sacred" birch tree. Above left: Rosemarie Leary on her wedding day. Above right: Jack and Susan Leary. Bottom: Timothy Leary mowing the lawn.

Rosemarie and I are American eagles. Totem animals of this land. Wild. Free. High. Proud. Laughing. Our children, Susan and John, are eaglets.

Counterclockwise: Peggy Hitchcock and manager of the rock group the Grateful Dead, Ron Rakow; Alan Atwell, psychedelic mandalic artist; Wavy Gravy (formerly Hugh Romney), second from the left, his guru, Swami Ananda, with a picture of Sri Ramana Maharshi; an American Indian resident of Millbrook in her regalia; Billy Hitchcock, owner of the Millbrook estate, in his bungalow.
Center: Austin Delaney, devotee of the Divine Mother, an emissary to Millbrook from Pondicherry, India.

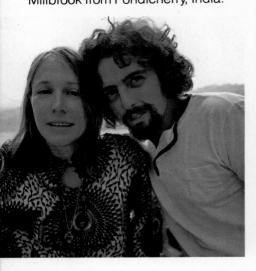

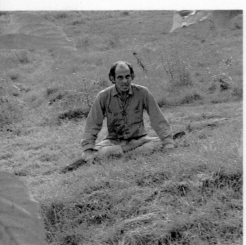

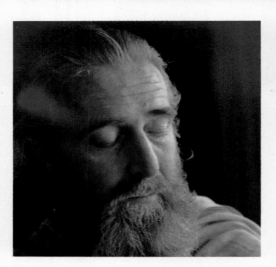

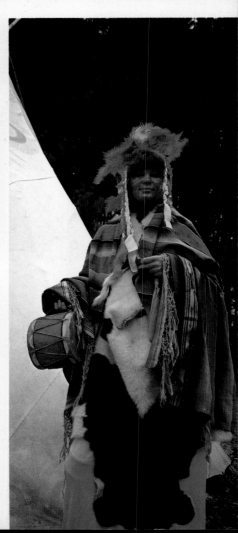

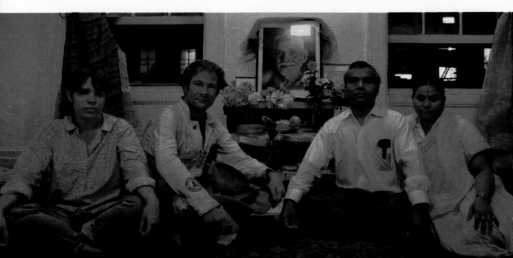

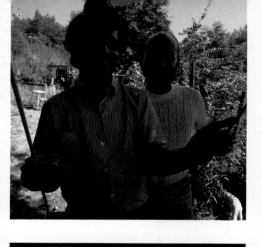
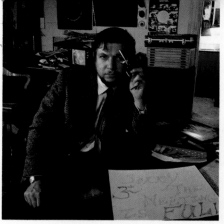
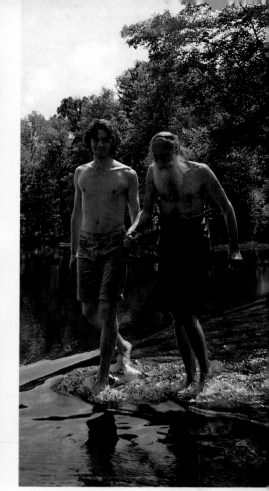

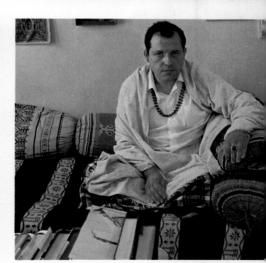

Above: Jack Wildeman and the late Swami Fred Swain; William Burroughs in Ira Cohen's Mylar Chamber in New York City. Center column from top: Doctor Joseph Gross, dream researcher; Ed Mays, Millbrook gardener; Allen Ginsberg recording the songs of William Blake; Parapsychologist Dr. Stanley Krippner at the Maimonides Hospital Dream Laboratory in Brooklyn, New York. Right column from top: Brother Day and Father Shiva; Bill Haynes, guru of Sri-Ananda Ashram. Art Kleps, chief BooHoo of the Neo-American Church, in the gatehouse bridge at Millbrook.

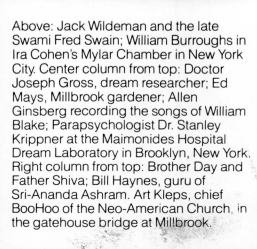

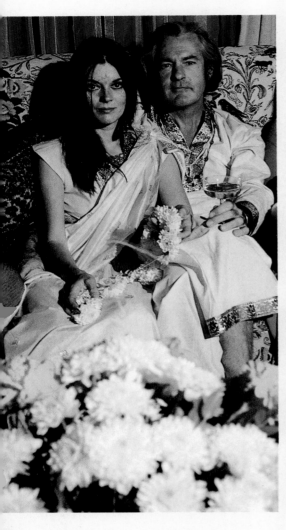

Above left: Timothy and Rosemarie Leary on their wedding day. Above: Richard Alcroft, light projection artist, inventor of the "infinity projector," and Barbara Taliaferro. Opposite: Timothy Leary on his horse Silver in front of the Big House at Millbrook. *Unexpected space-time dimensions left me feeling exhilarated, awed and quite convinced that I had awakened from a long ontological sleep.*

OVERLEAF. An American yogi meditating in the Berkshires, Massachusetts.

SECOND OVERLEAF. Ultraviolet/black light paintings in the Us Co. Church Audiovisual Meditation Temple, Garnerville, New York.

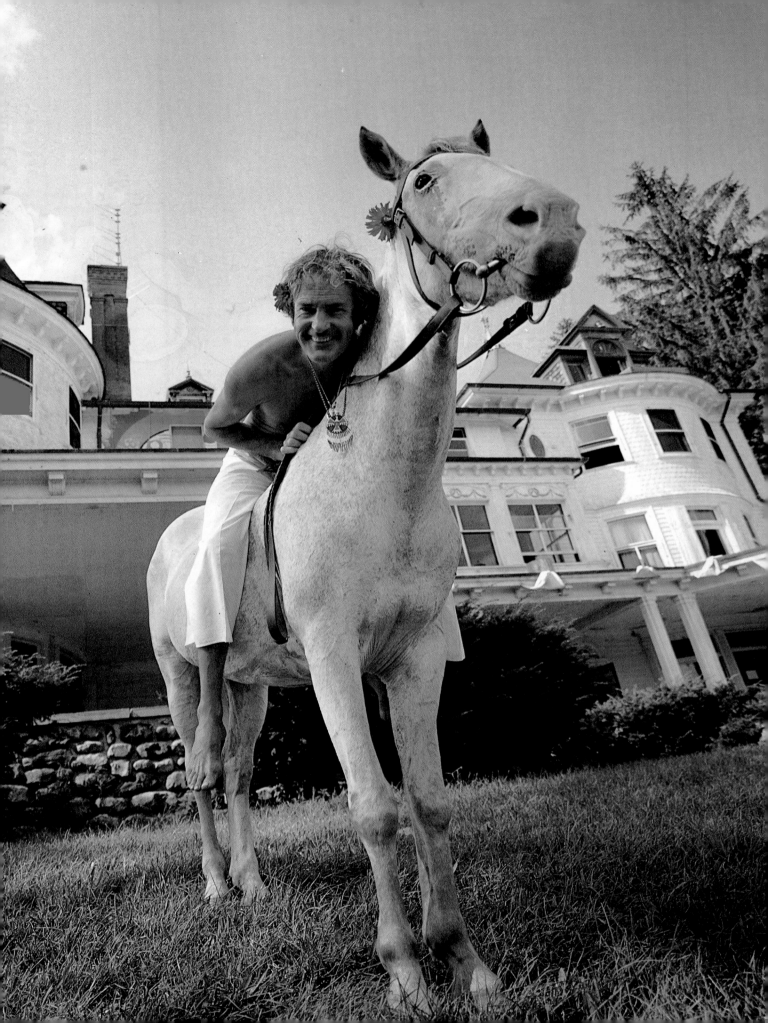

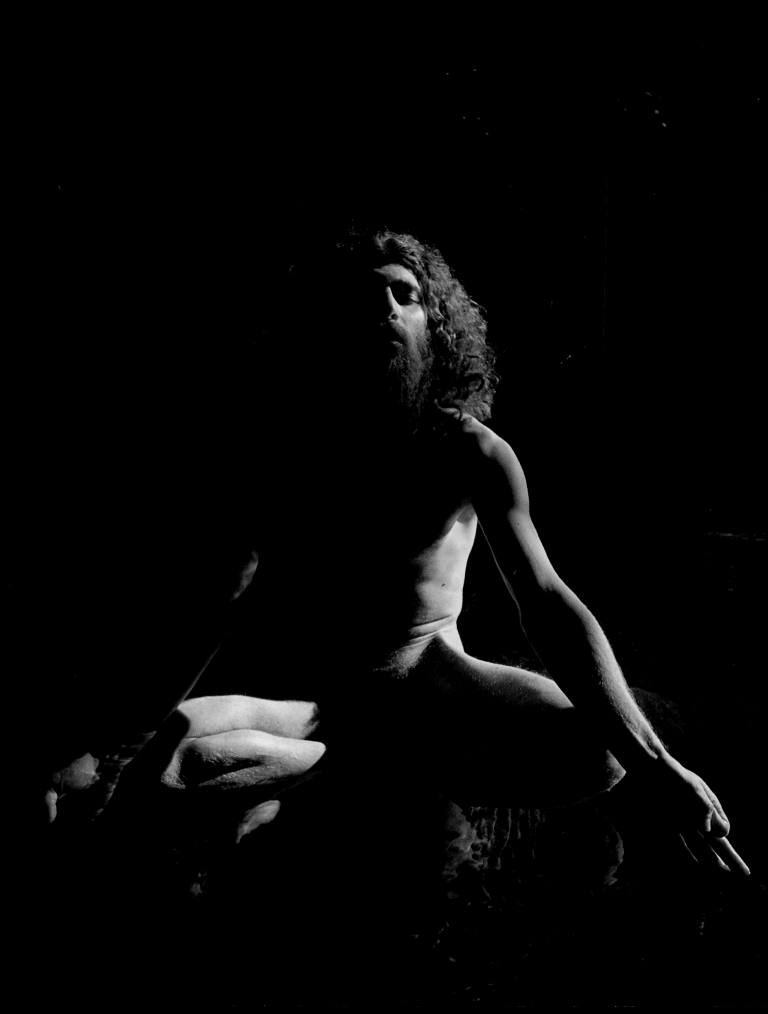

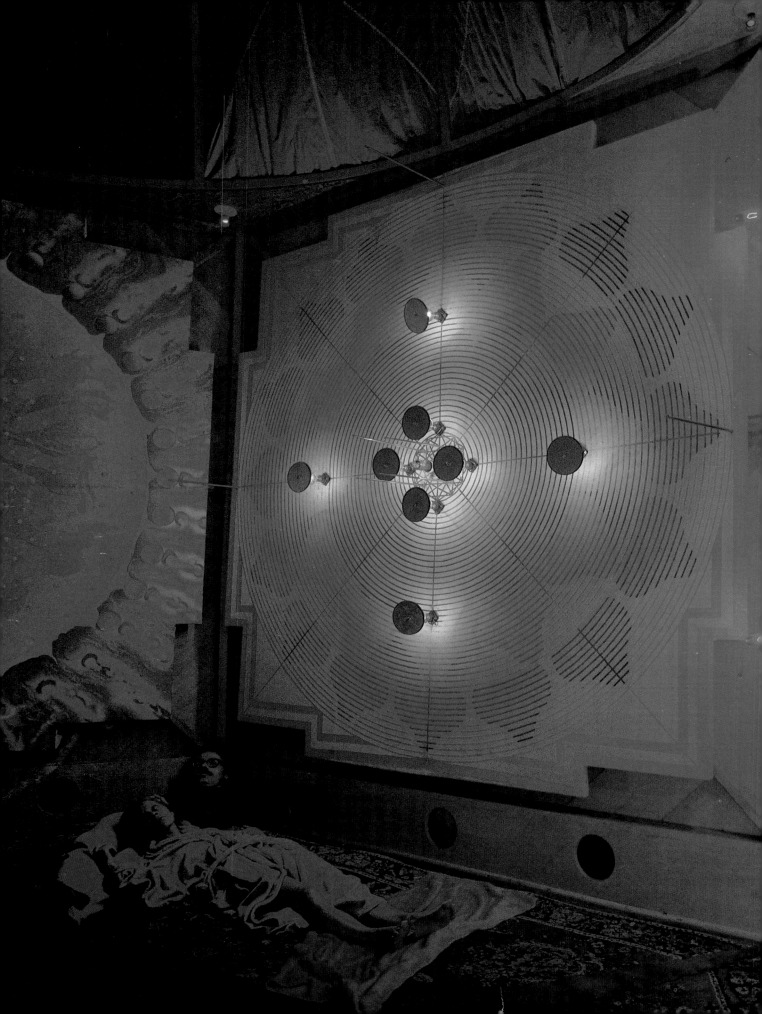

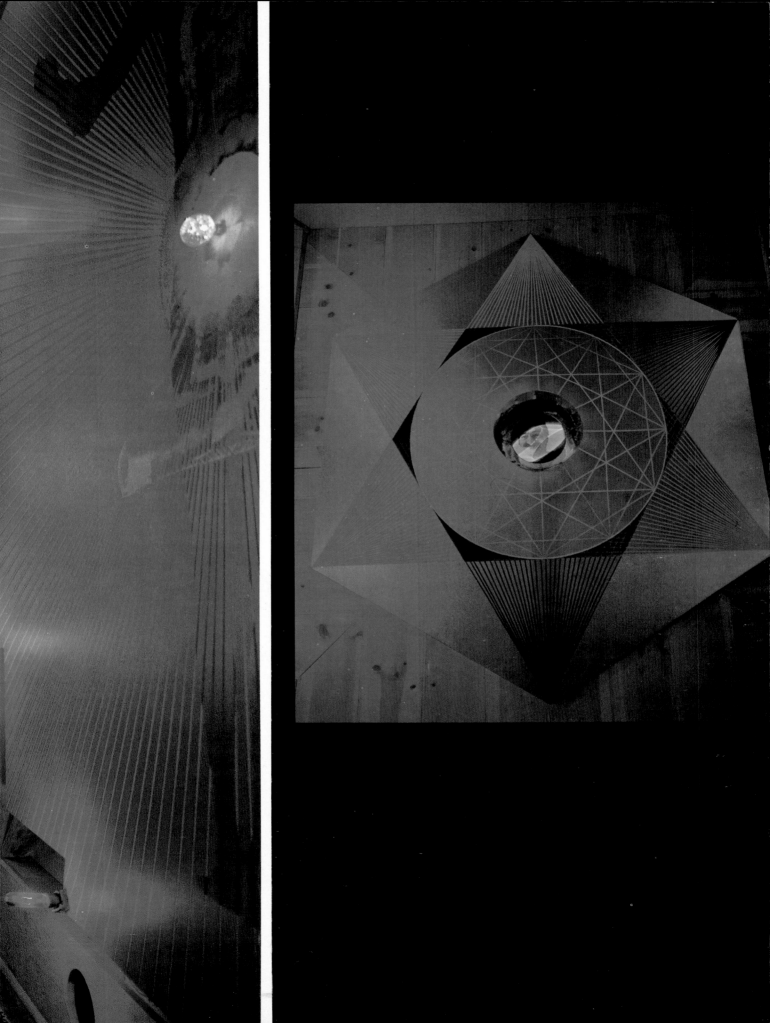

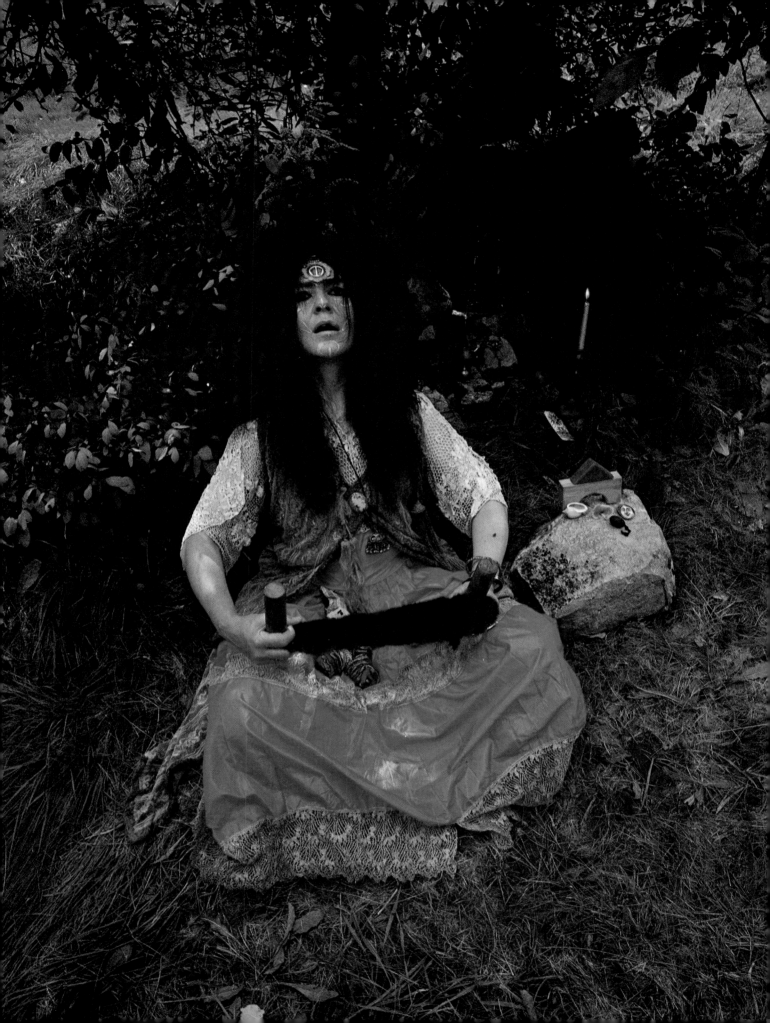

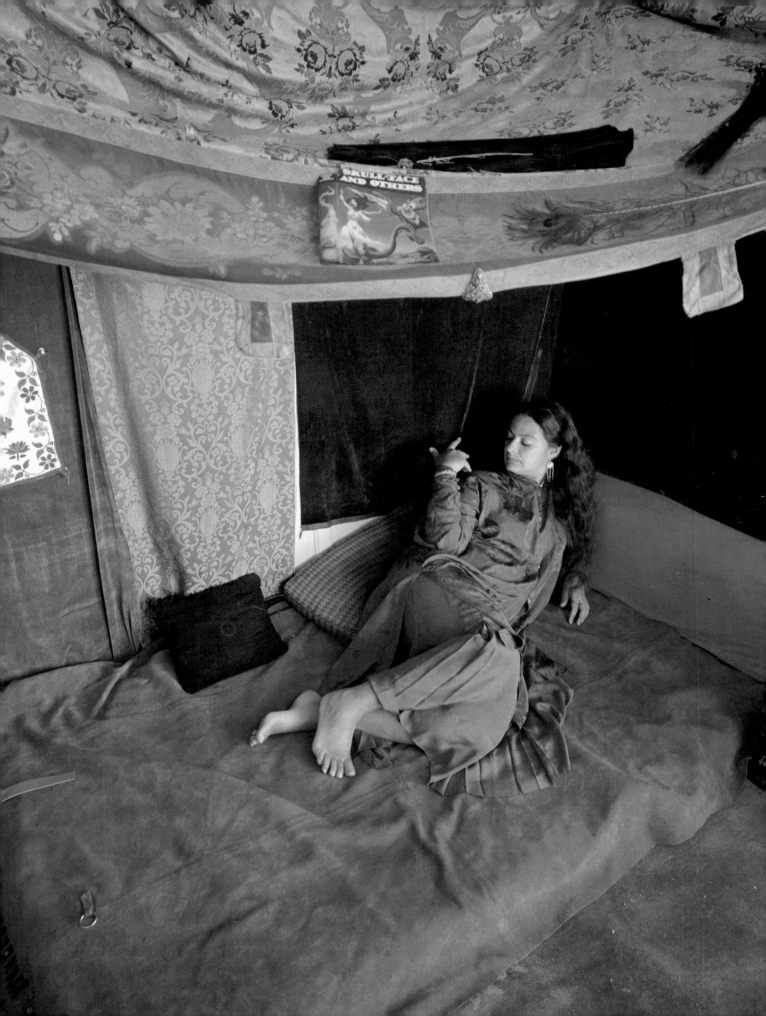

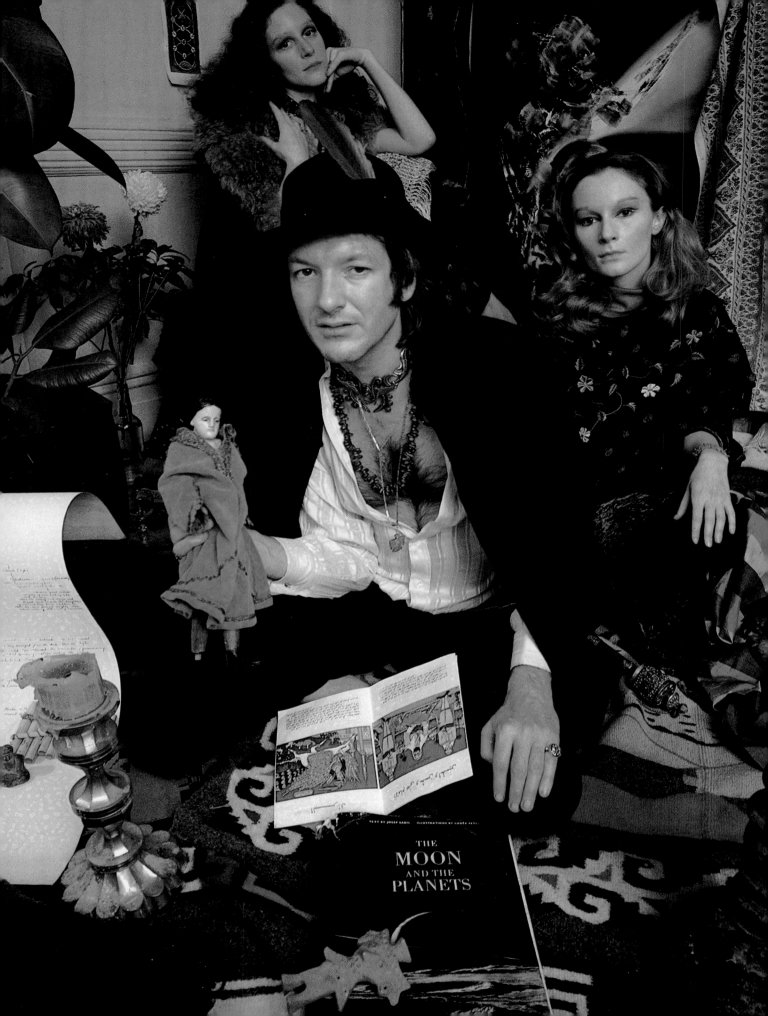

THE
MOON
AND THE
PLANETS

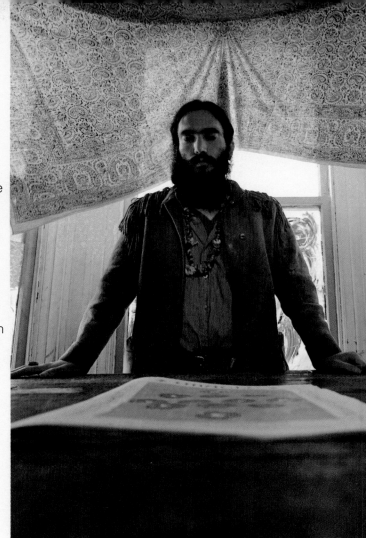

Opposite: Aymon de Roussy de Sales, artist and cartographer, with Susan and Pauline, New York City. Upper right: Allen Cohen, editor of the *San Francisco Oracle,* the first "flower power" newspaper. Lower right: Ira Cohen and Lionel Ziprin, poets, mystics, and scholars, confer on the Zohar in a Jefferson Street loft in New York City.

PRECEDING PAGES. Left: Seer Hetty MacLise, mother of Ossian, who later became Rinpoche of Swayambu Monastery in Kathmandu, Nepal, in the Berkshires, Massachusetts. Right: Lenore Kandel, author of *The Love Book,* in her San Francisco boudoir.
There are no ways but love but/beautiful/
I love you all of them.

OVERLEAF. Far left: light projection. Upper left: Bob Masters, author of *Eros and Evil* with his wife and coauthor, Dr. Jean Houston, of *The Varieties of Psychedelic Experience,* with a statue of the ancient Egyptian deity Sekhmet. Lower left: Rudi Stern and Jackie Cassen, lumia artists, in their Sixth Avenue studio, New York City. Right: Dr. Jean Houston in the "witches' cradle," a "mind-alteration" device, New York City.

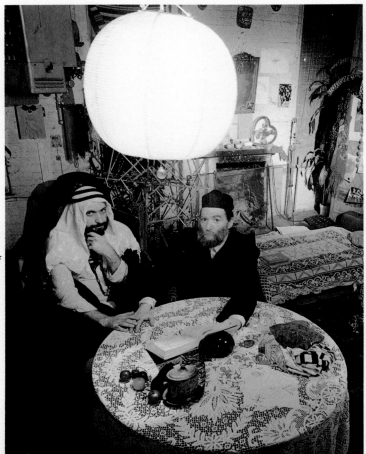

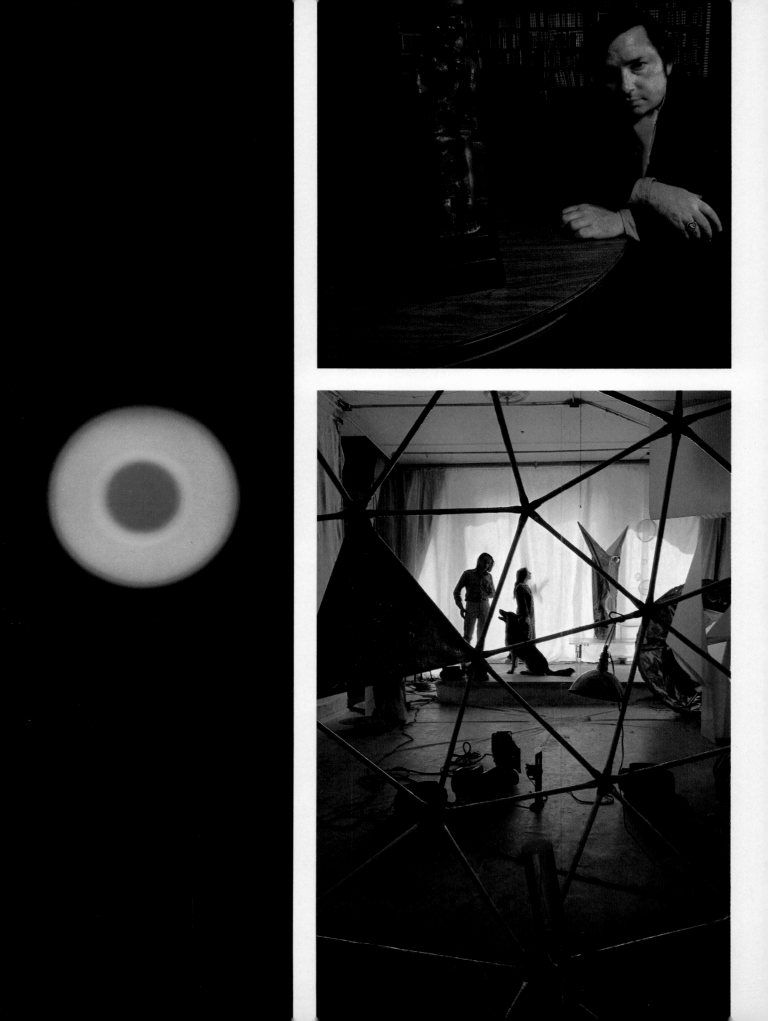

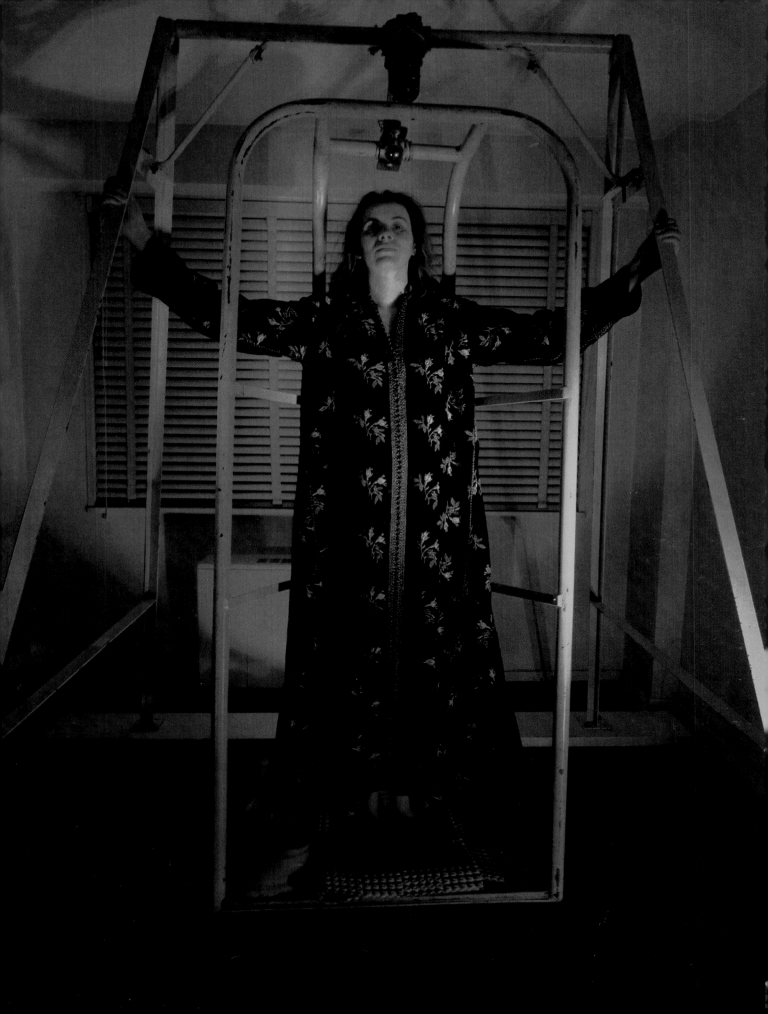

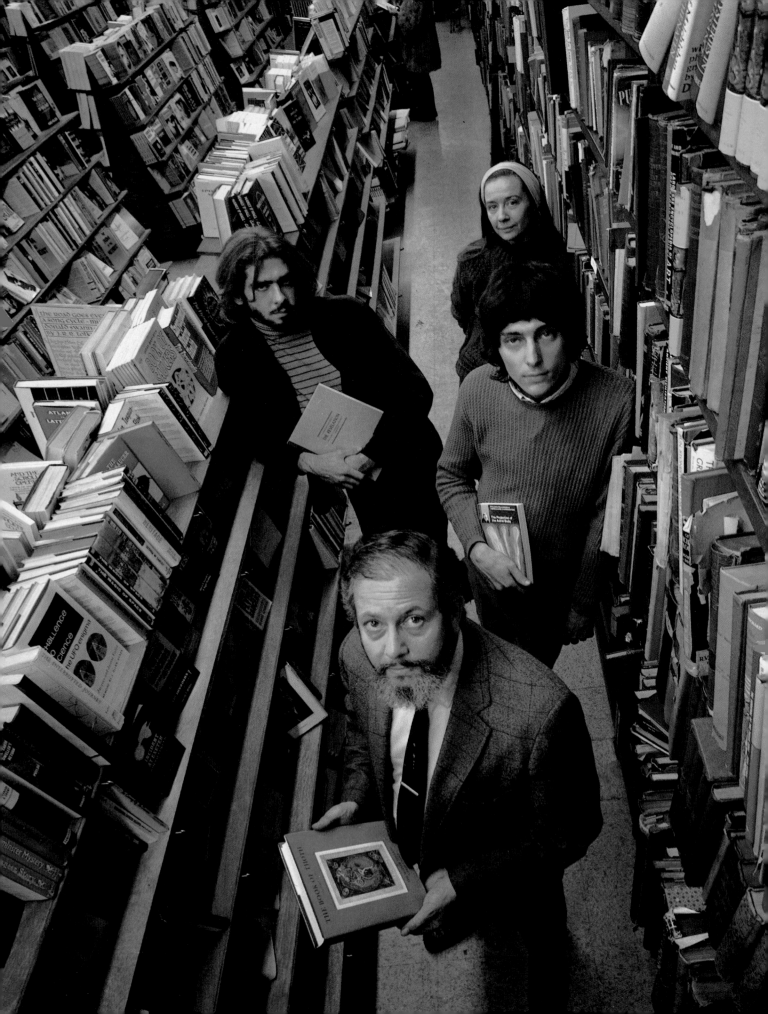

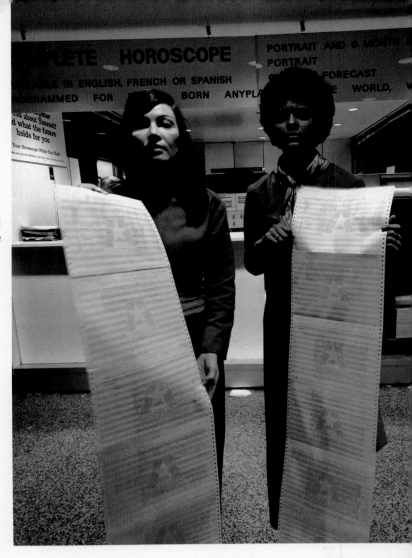

Left: The late Samuel Weiser and company, in his occult bookstore on Lower Broadway, New York City. Top right: The first Computer Astrology Center, Grand Central Station, New York City. Lower right: Erna Kaufman, follower of theosophist Rudolf Steiner, and her granddaughter, the Berkshires, Massachusetts.

OVERLEAF. Jill Sands in Northern California. *It is the poet's work to create living myths, that is, history.* Right: Leslie Brennan, writer and editor, *through the looking glass,* in New York City.

SECOND OVERLEAF. A mirage: Lionel Ziprin and H. Cohen in Ira Cohen's film, *Thunderbolt Pagoda.*

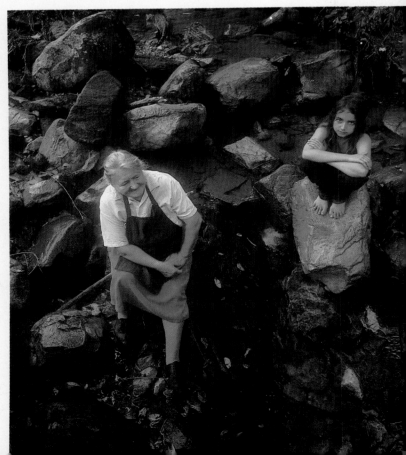

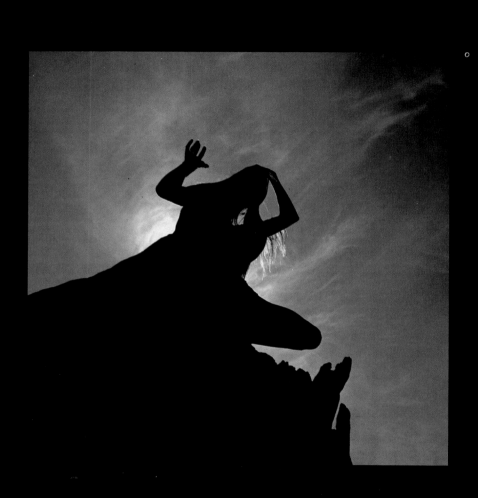

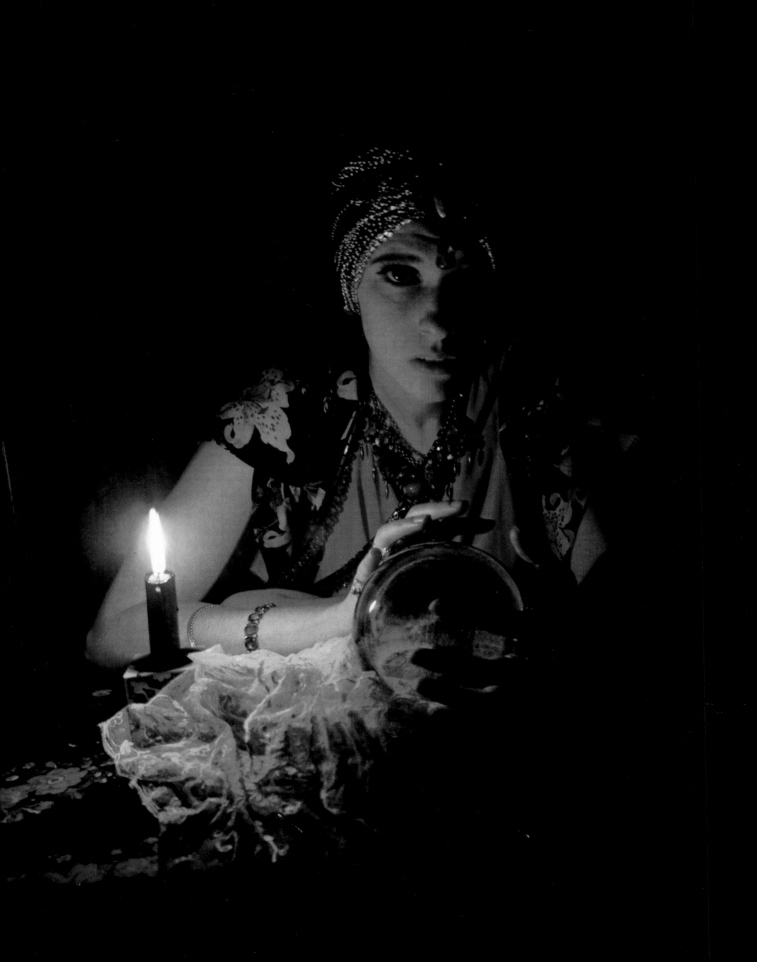

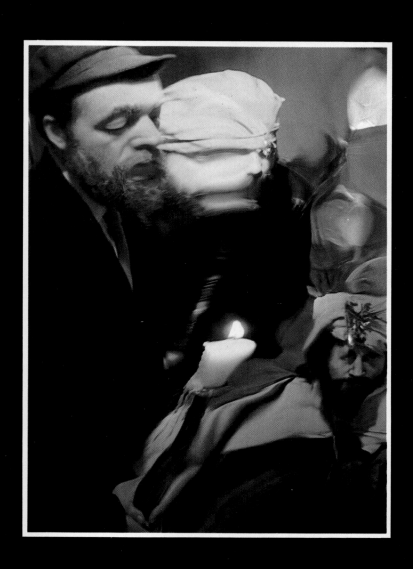

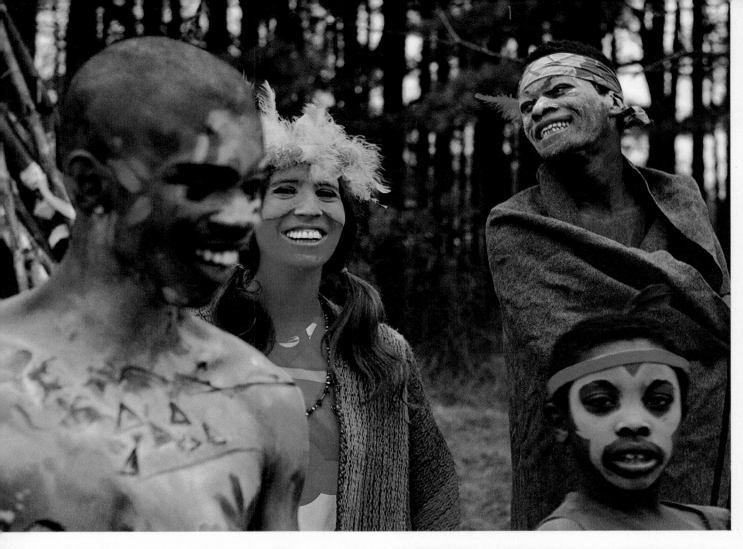
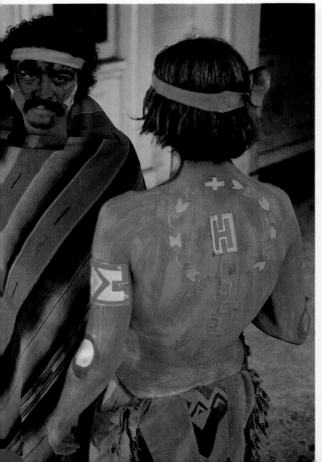

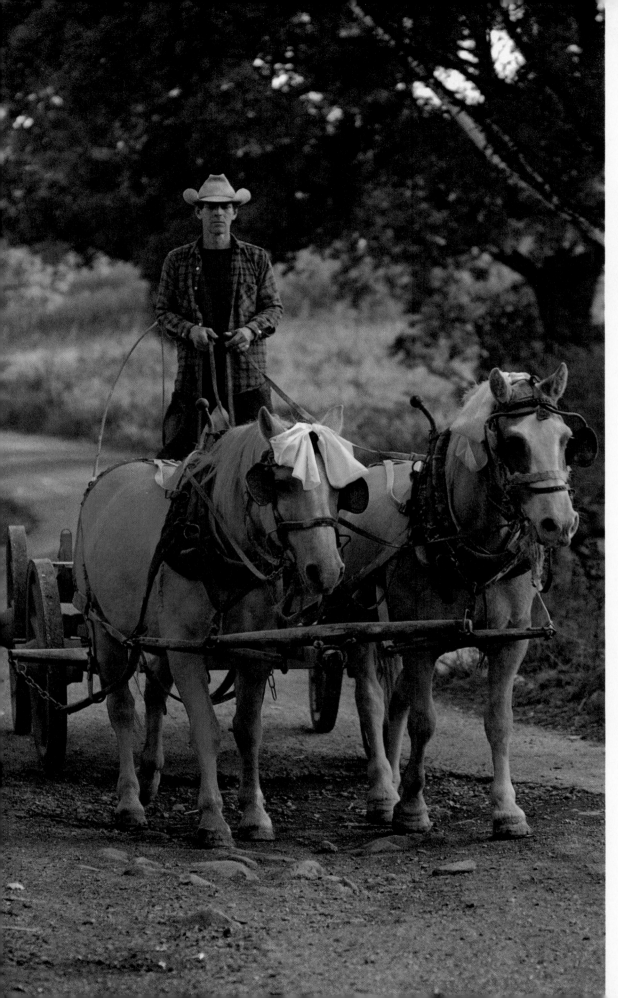

Left: Actors from the "third world" movie production at Millbrook.

PRECEDING PAGES. Margaret Whitton, Rick Robbins, and Charles Giuliano, at the Green River, the Berkshires, Massachusetts.

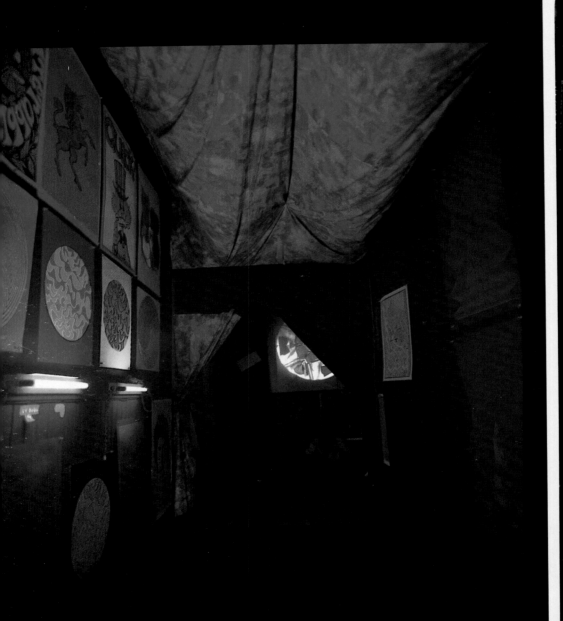

Interior and exterior of the Electric
Lotus, an East Village headshop,
New York City.

PRECEDING PAGES. Hippies in
Haight-Ashbury, San Francisco.

OVERLEAF. Top right: Actresses
Hollis and Holly, mother and
daughter. Lower left and right:
"The Gates of the Soft Mystery," a
human mandala in the Berkshires,
Massachusetts.

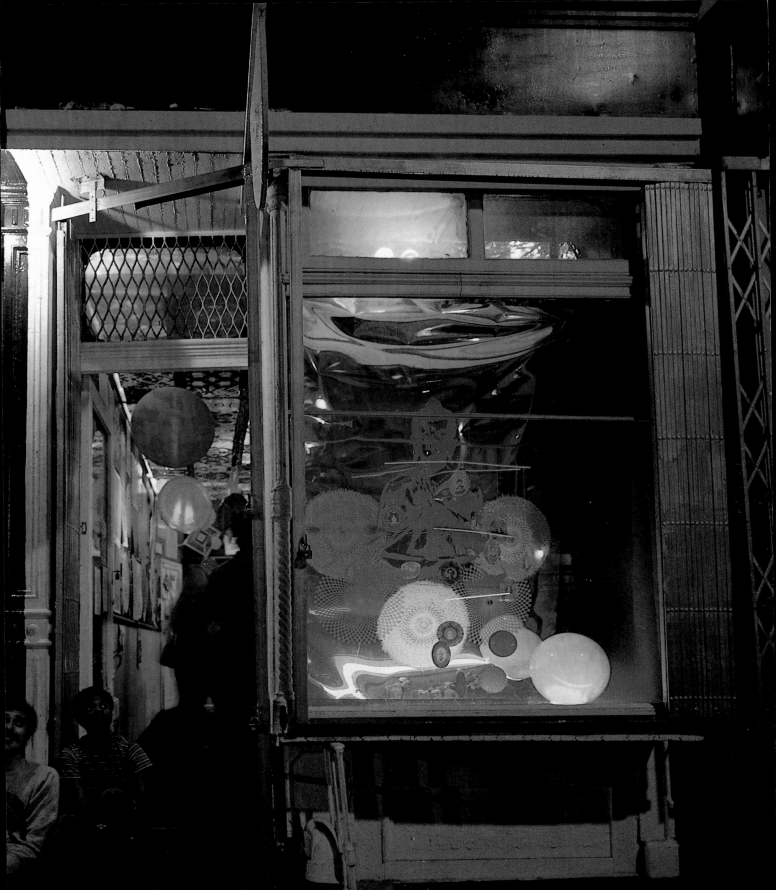

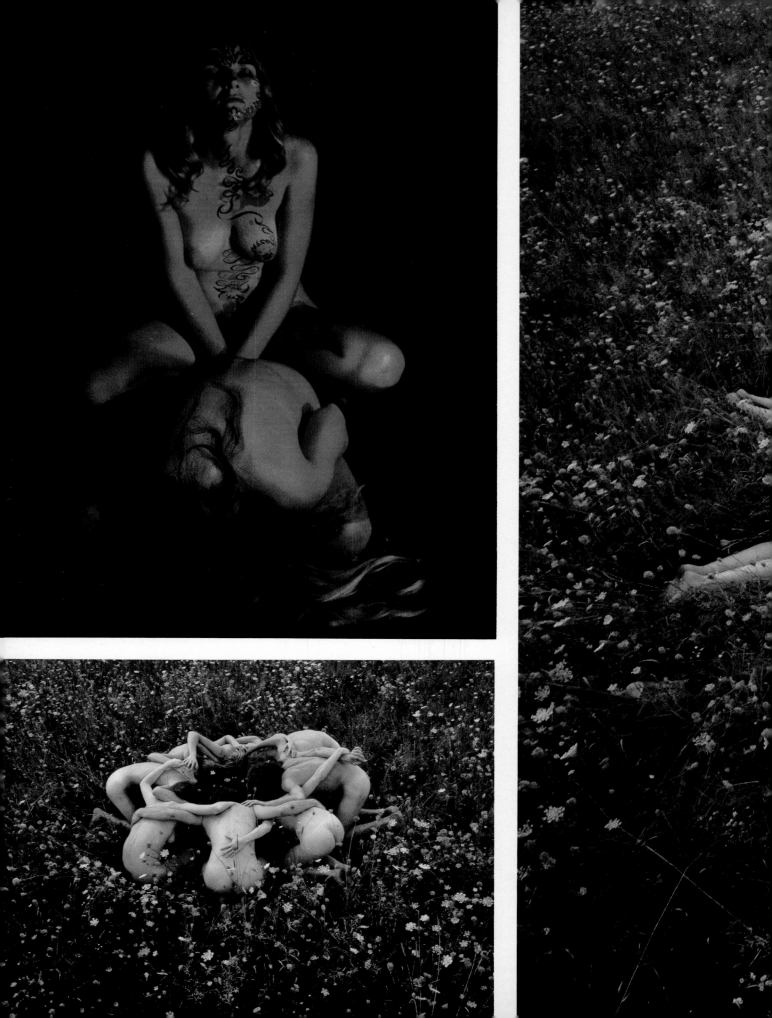

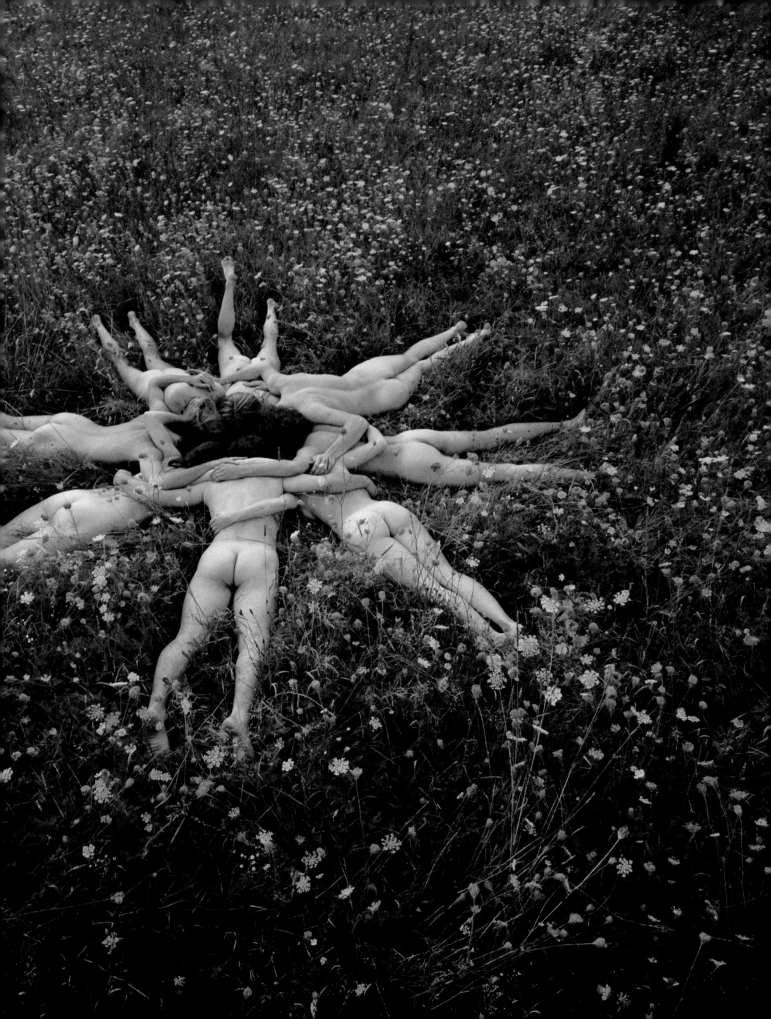

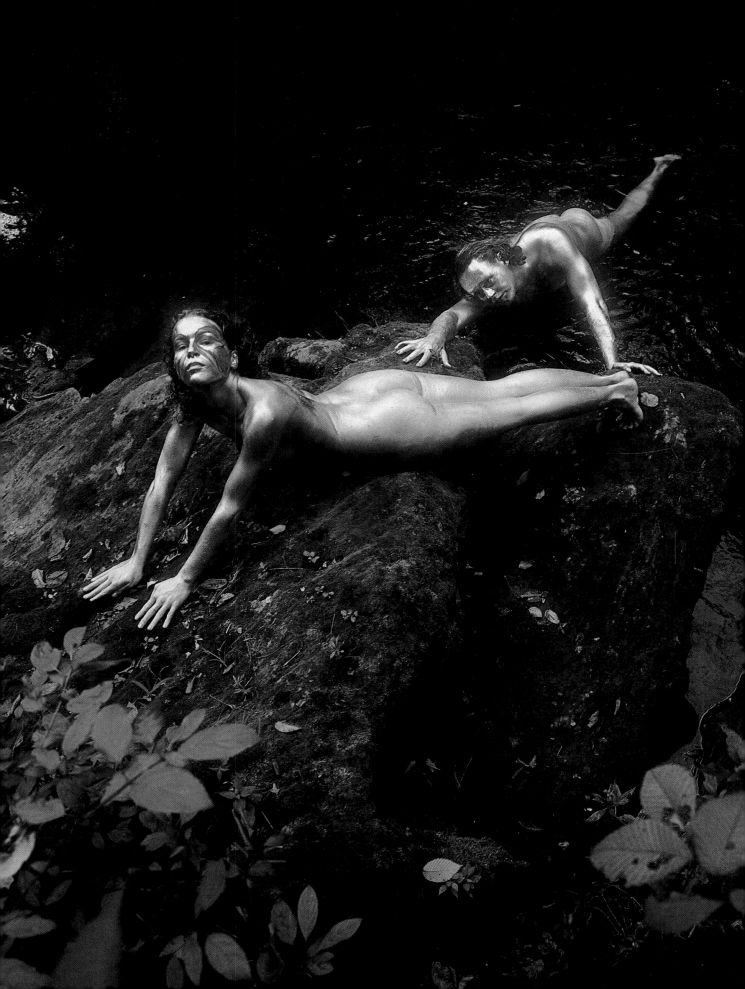

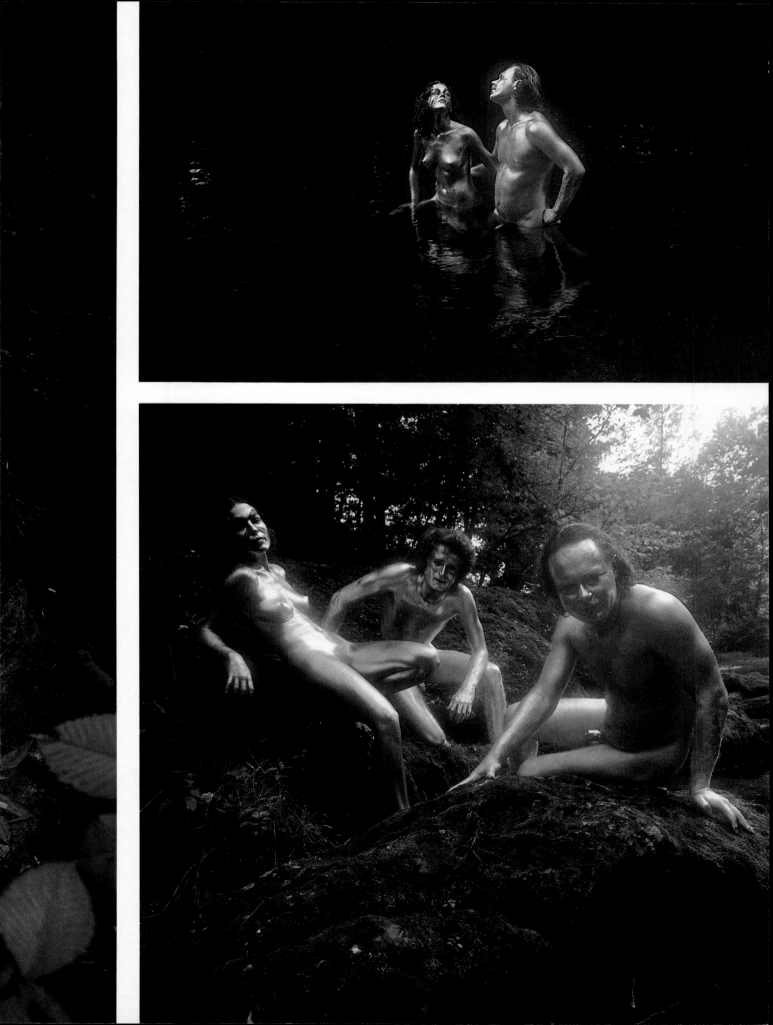

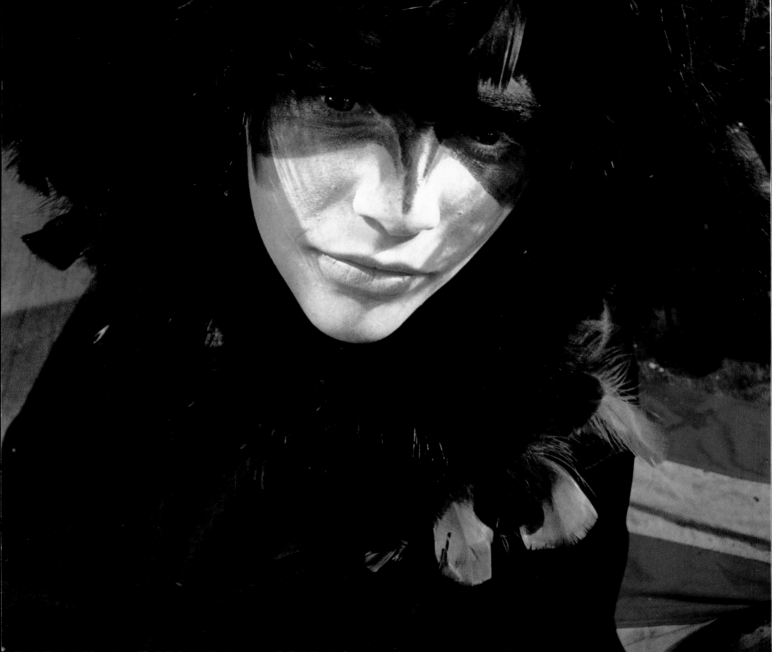

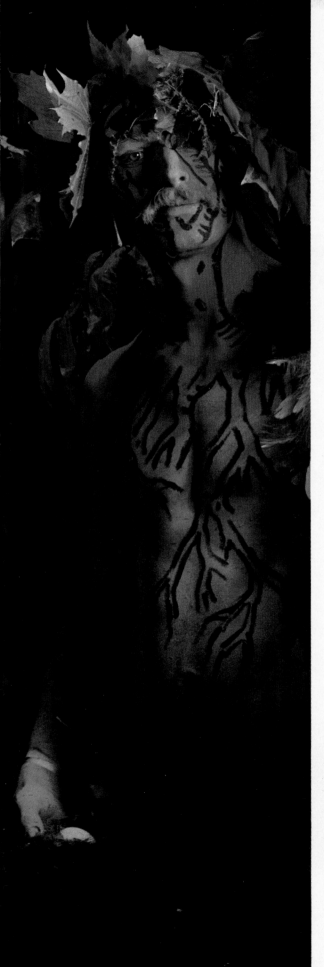

Left: Other apparitions at Millbrook. Right: Snyder projections on a nude.

OVERLEAF. Left: Walter Bowen, psychedelic artist, San Francisco. Left: Michael Hollingshead, author of *The Man Who Turned On the World*, Cambridge, Massachusetts.

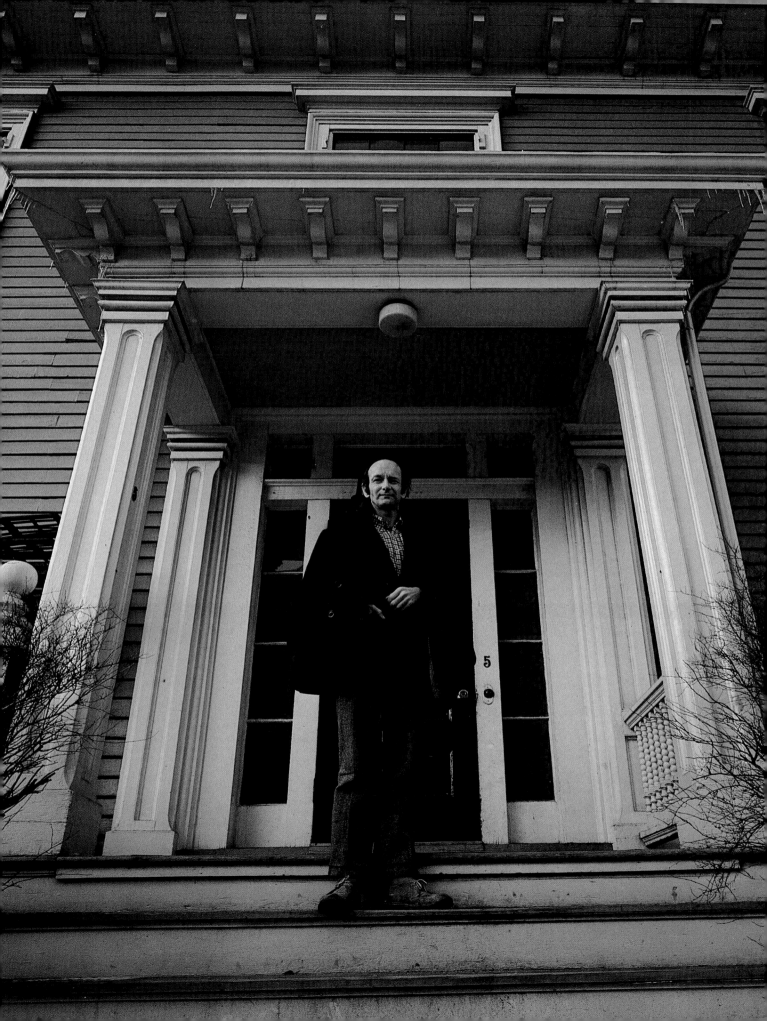

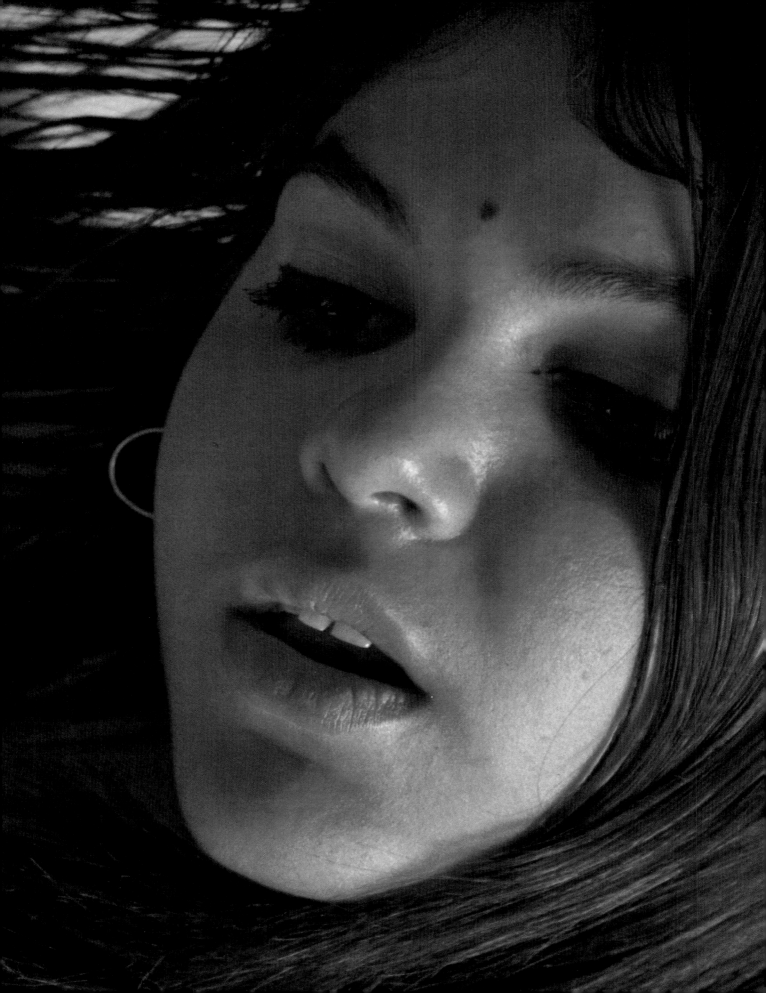

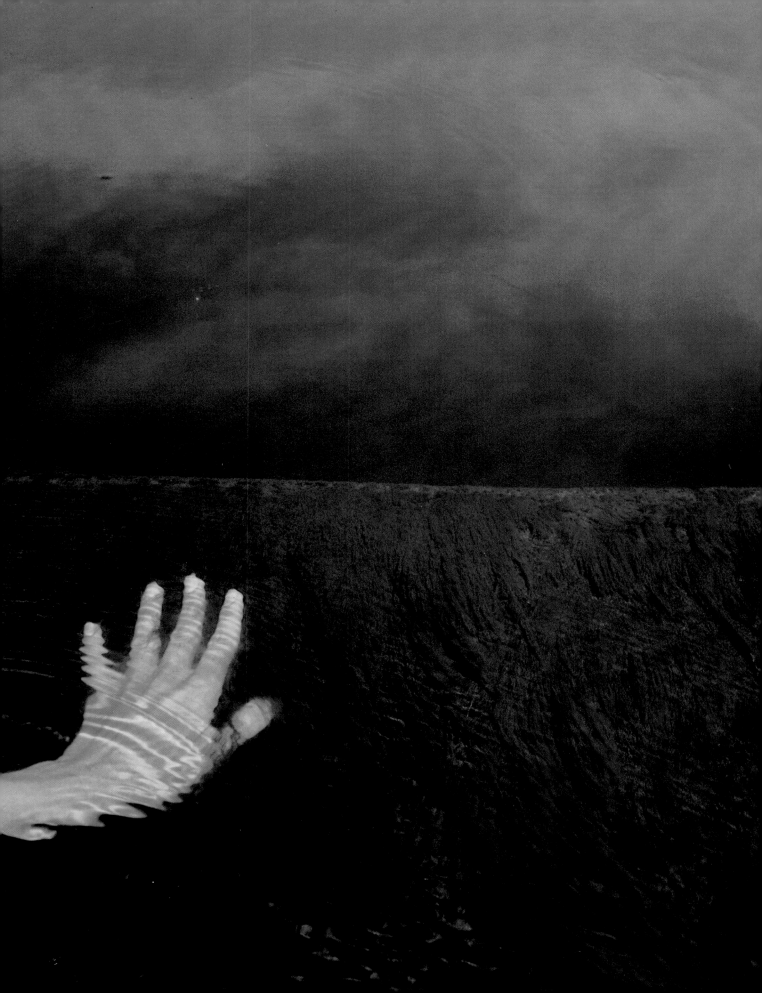

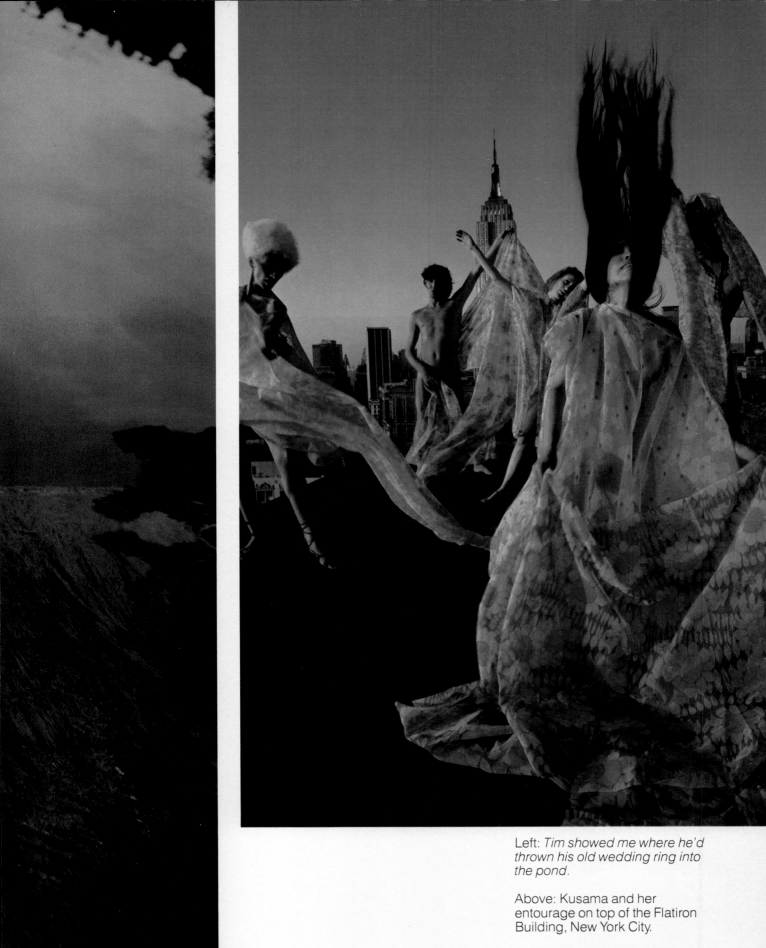

Left: *Tim showed me where he'd thrown his old wedding ring into the pond.*

Above: Kusama and her entourage on top of the Flatiron Building, New York City.

OVERLEAF. The Print Mint, psychedelic poster shop, Haight-Ashbury, San Francisco.

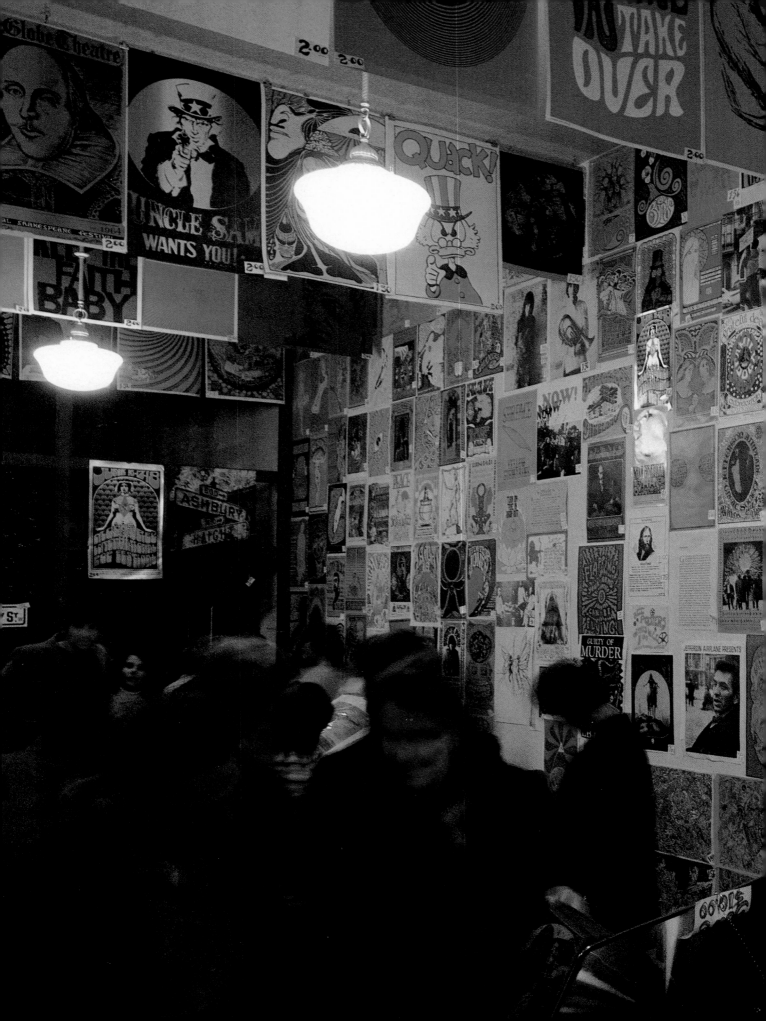

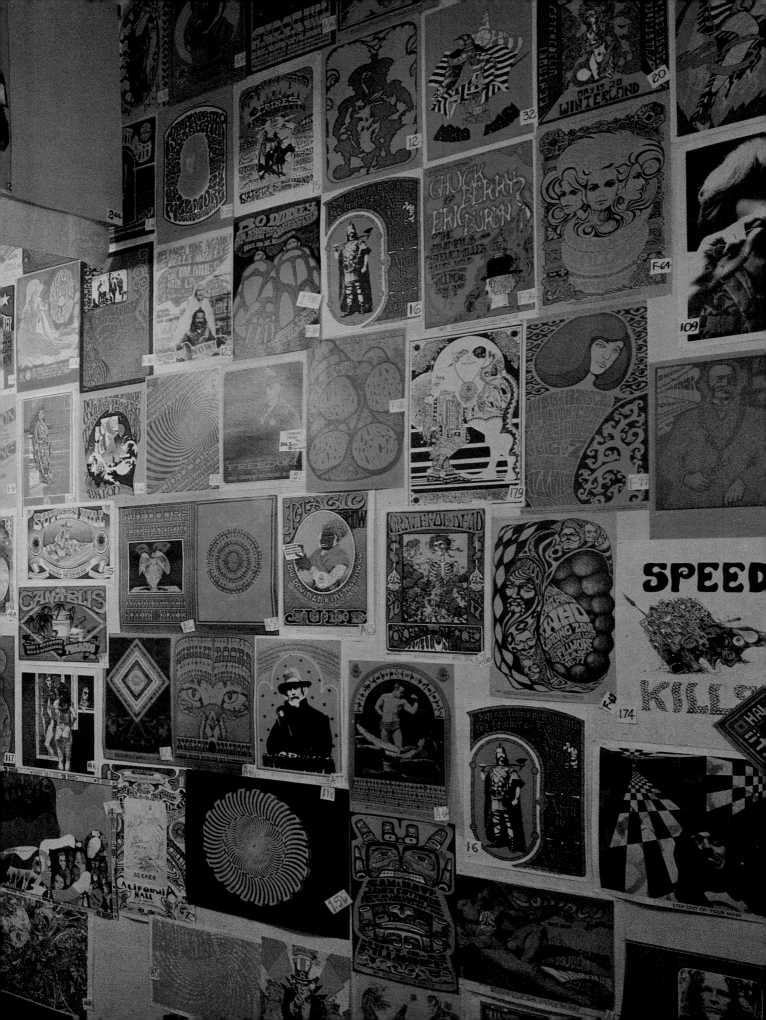

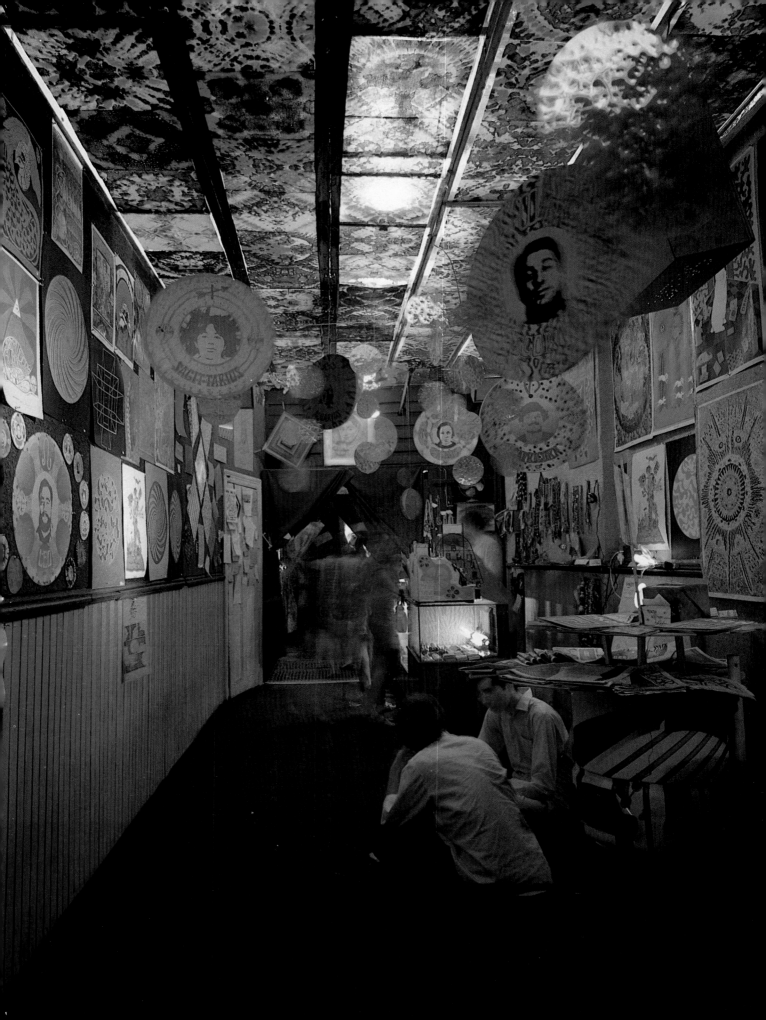

Far left and top right: Tie-dyed
fabrics on the ceiling of a
headshop in New York City.
Lower right: Headshop in San
Francisco.

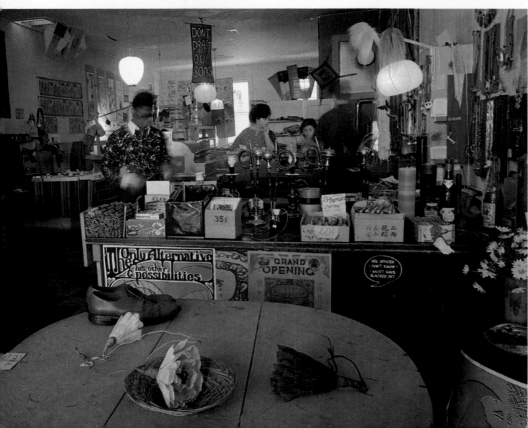

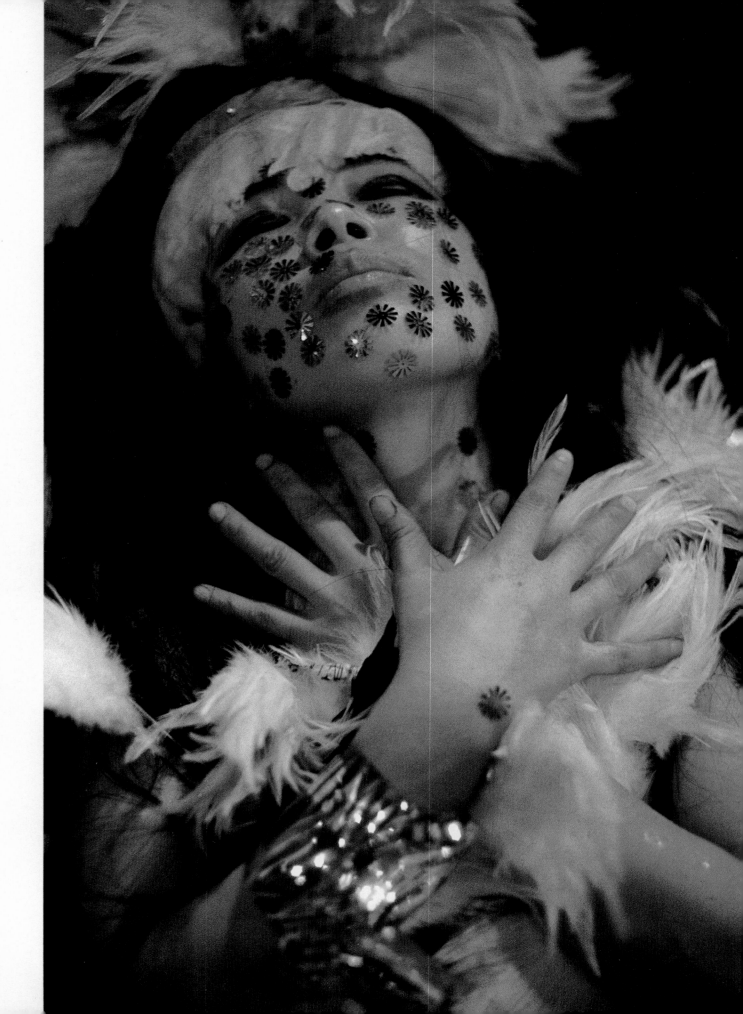

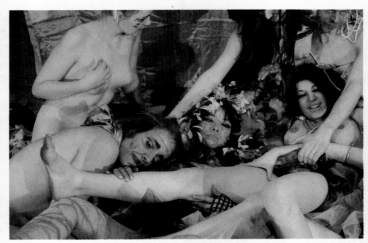

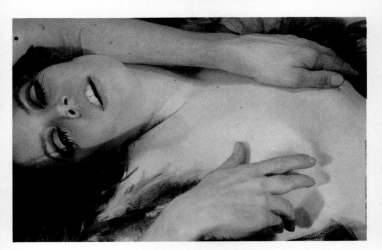

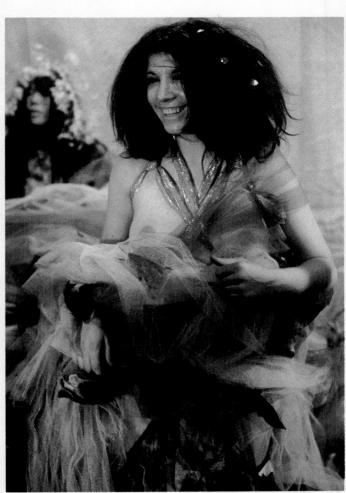

Far left: Kusama as the high priestess of her "self-obliteration ceremonies." Right: Kusama's "orgy creations."

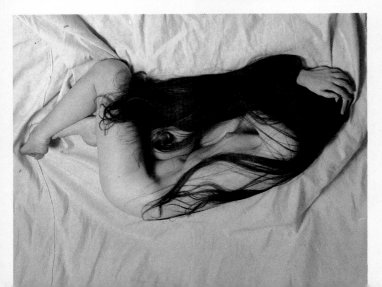

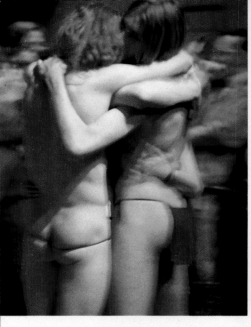

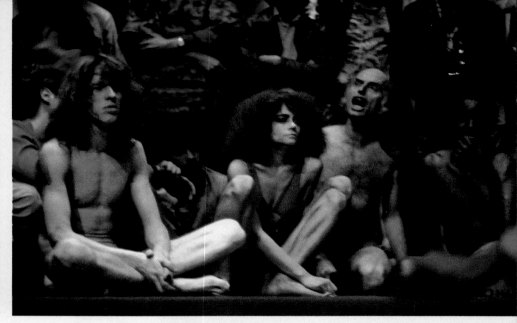

The Living Theatre's production of *Paradise Now,* at the Brooklyn Academy of Music, written and directed by Julian Beck (upper right) and Judith Malina. The play was structured around a series of rites, actions, and visions, which encouraged the participation of the audience.

It is a voyage from the many to the one and from the one to the many. It's a spiritual voyage and a political voyage. —Julian Beck. Overleaf: "The Rite of Universal Intercourse." Second overleaf: "The Rite of Opposite Forces."

The purpose of the play is to lead to a state of being in which nonviolent revolutionary action is possible —Gianfranco Mantegna.

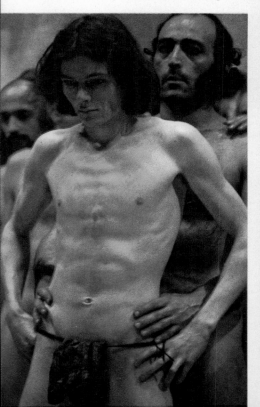

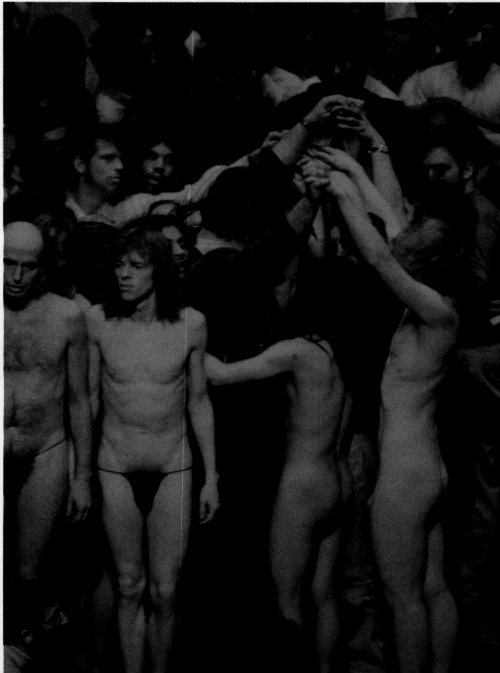

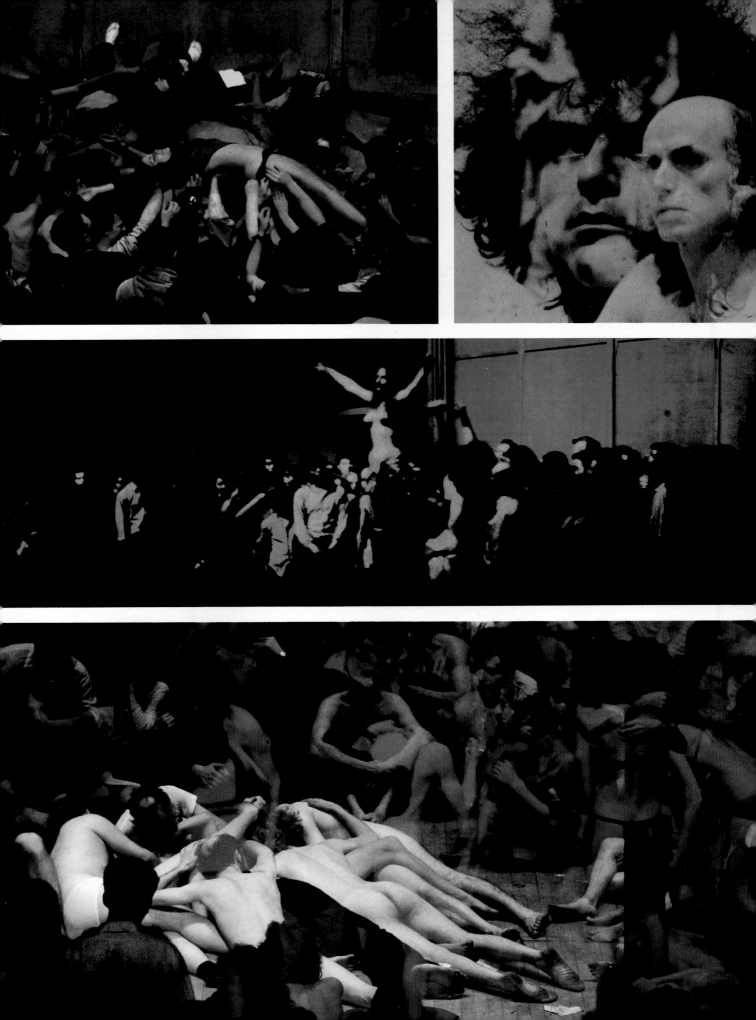

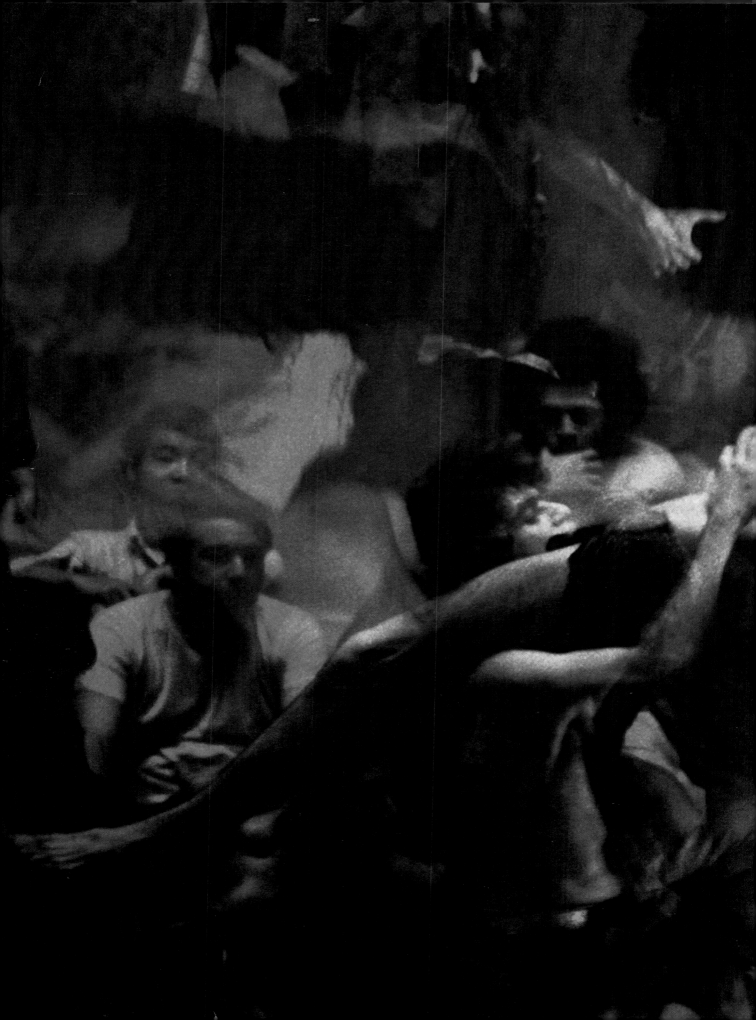

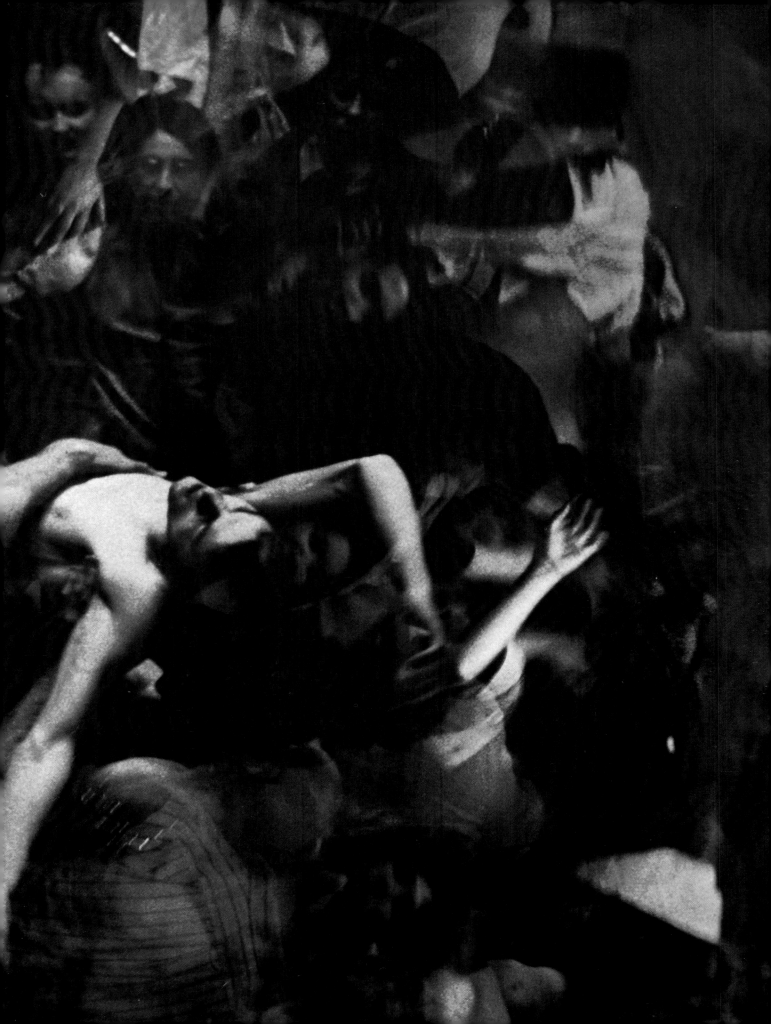

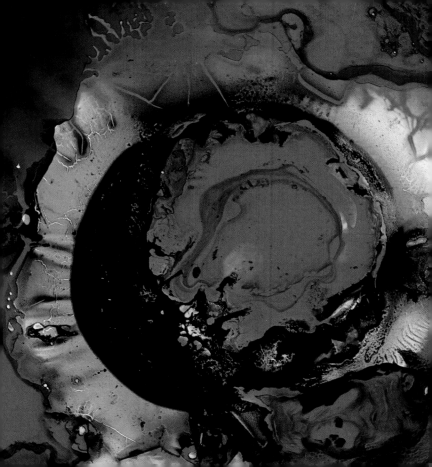

CIRCUS
CIRCUS

Right: The Dom and
the Electric Circus,
center of psychedelic
rock shows in St.
Mark's Place, New York
City. Top left: Polarized
projections on a nude.
Lower left: The Electric
Circus equipment
truck.

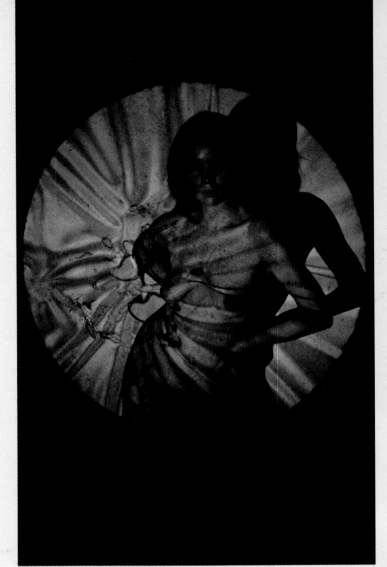

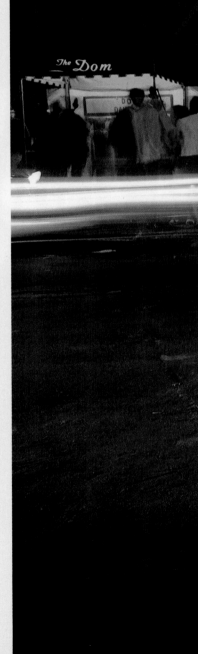

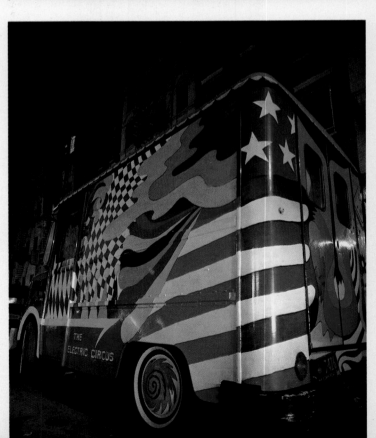

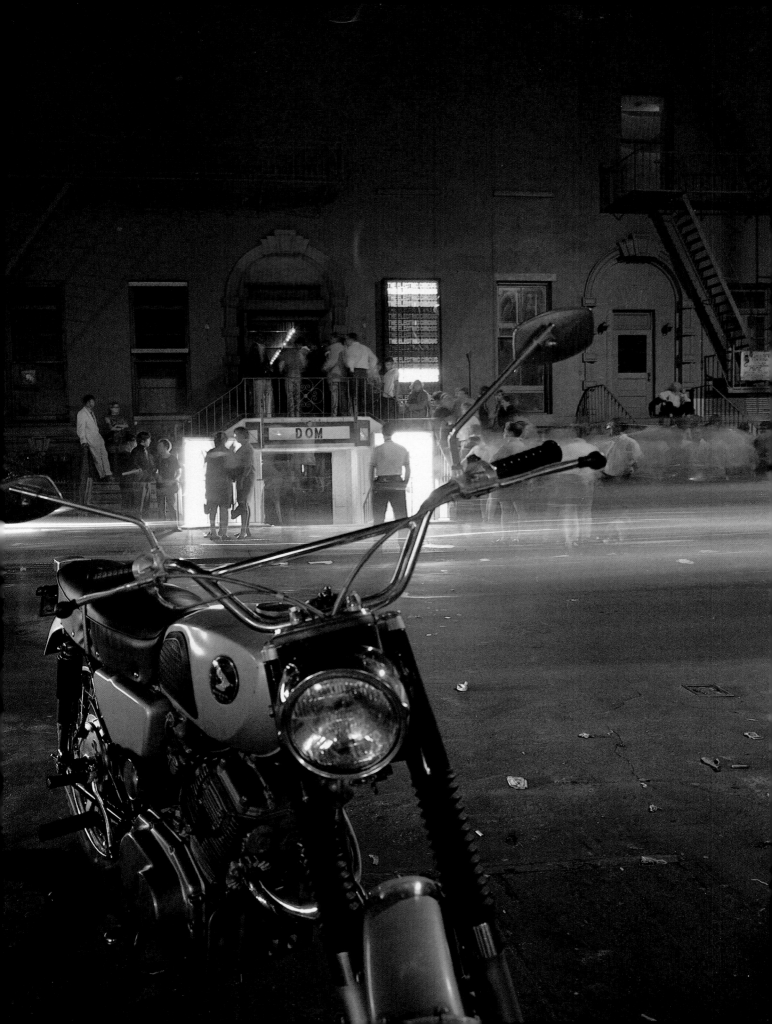

Center and lower left: The interior of the Electric Circus. Left, right, and overleaf: Psychedelic projections on nude dancers.

SECOND OVERLEAF. A light show benefit in the Bauhaus tradition of Moholy-Nagy, by Don Snyder, in St. Peter's Episcopal Church, New York City.

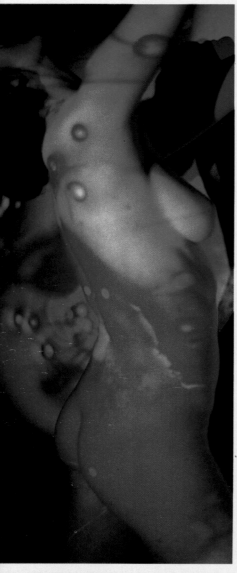

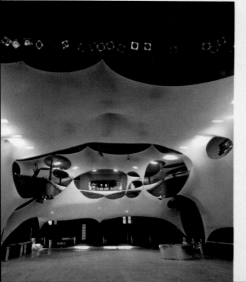

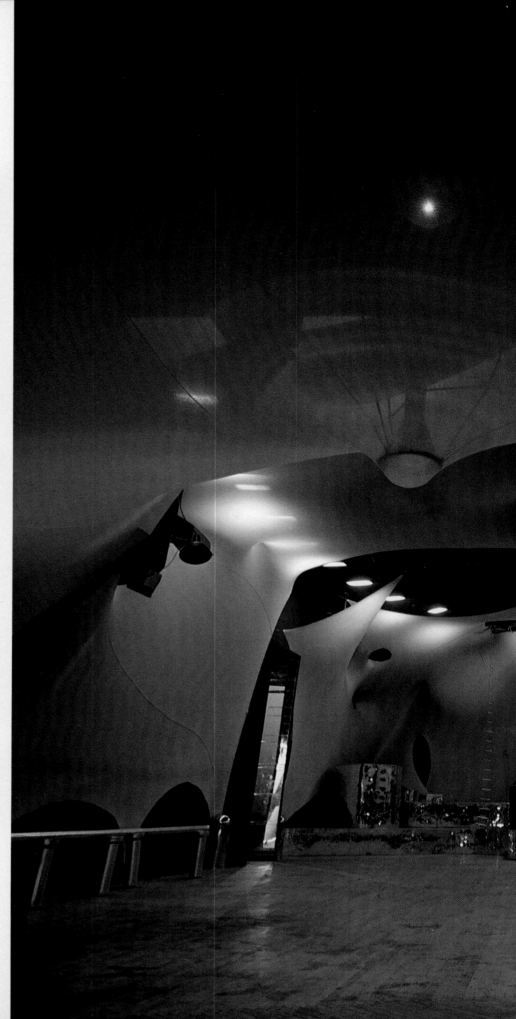

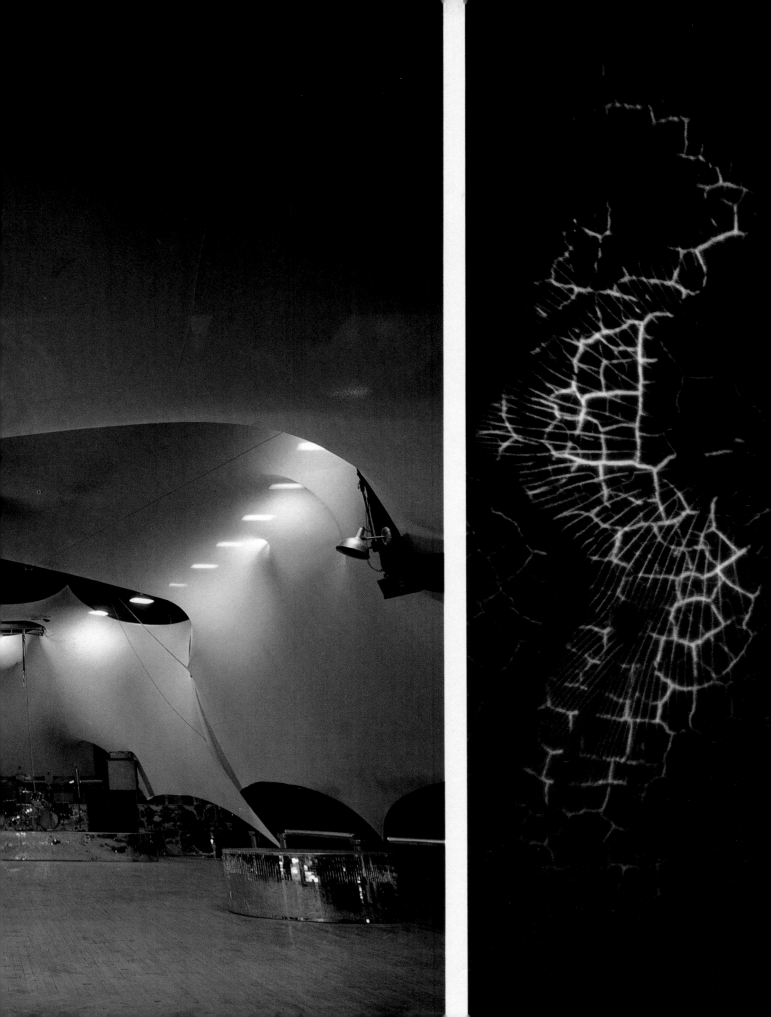

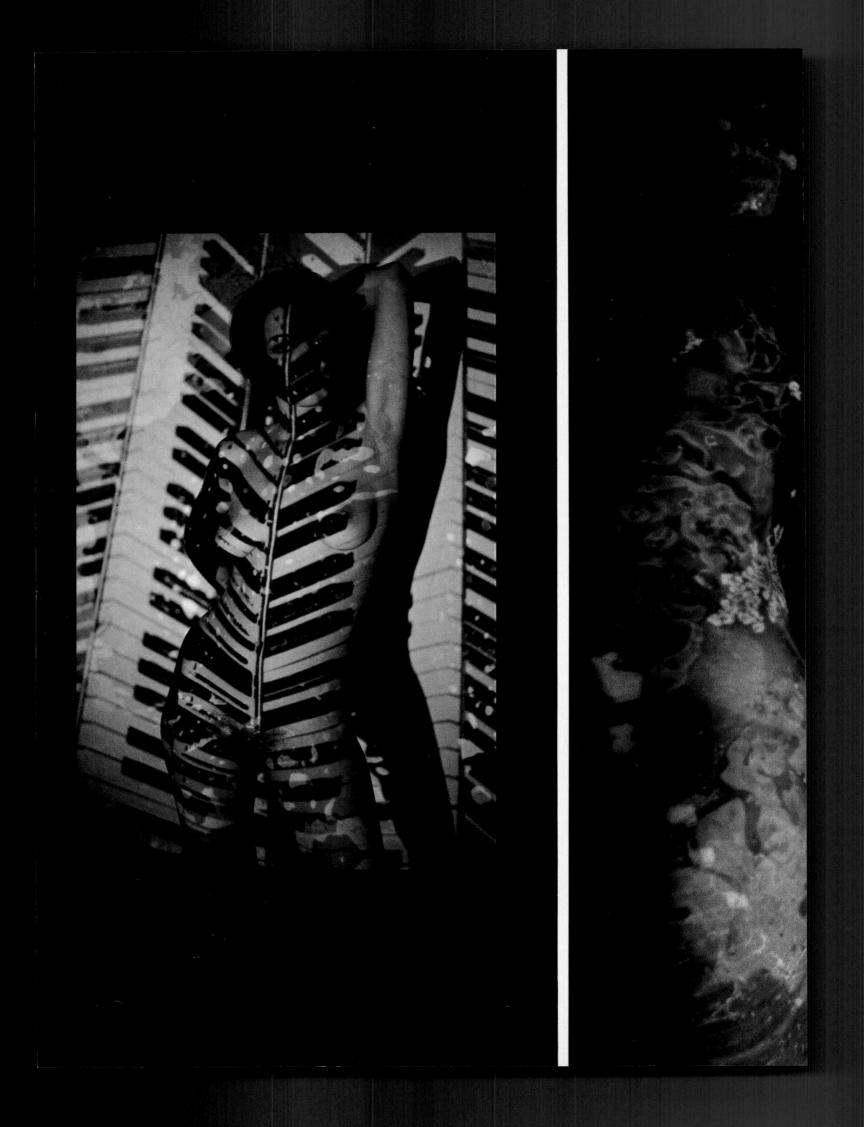

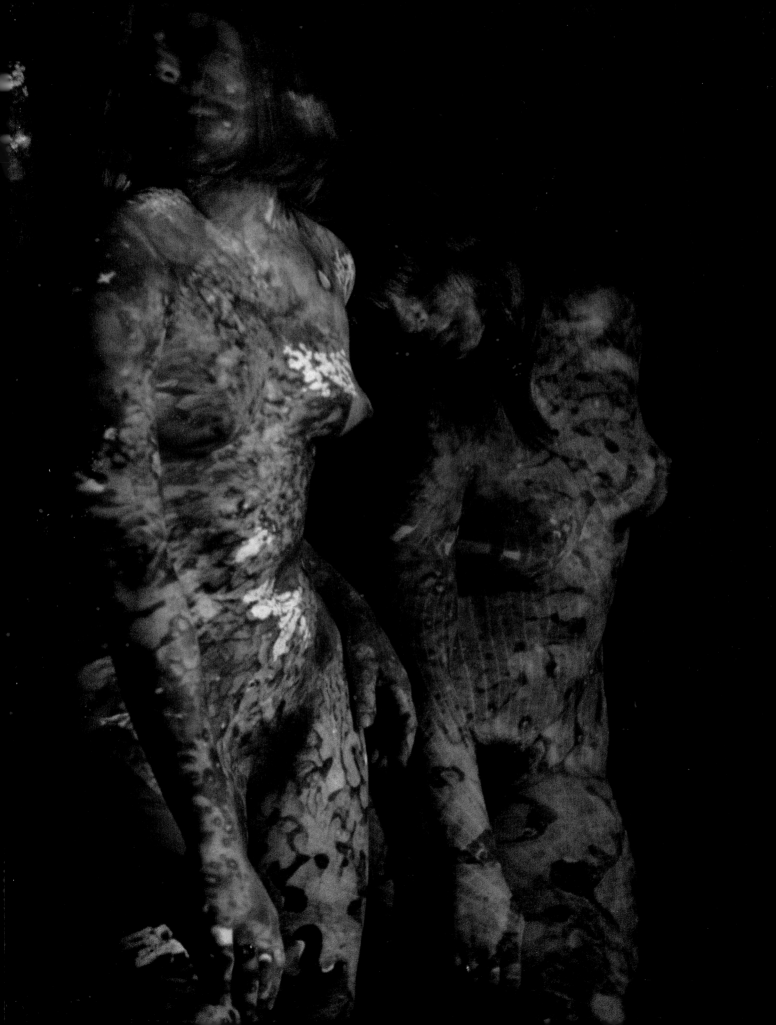

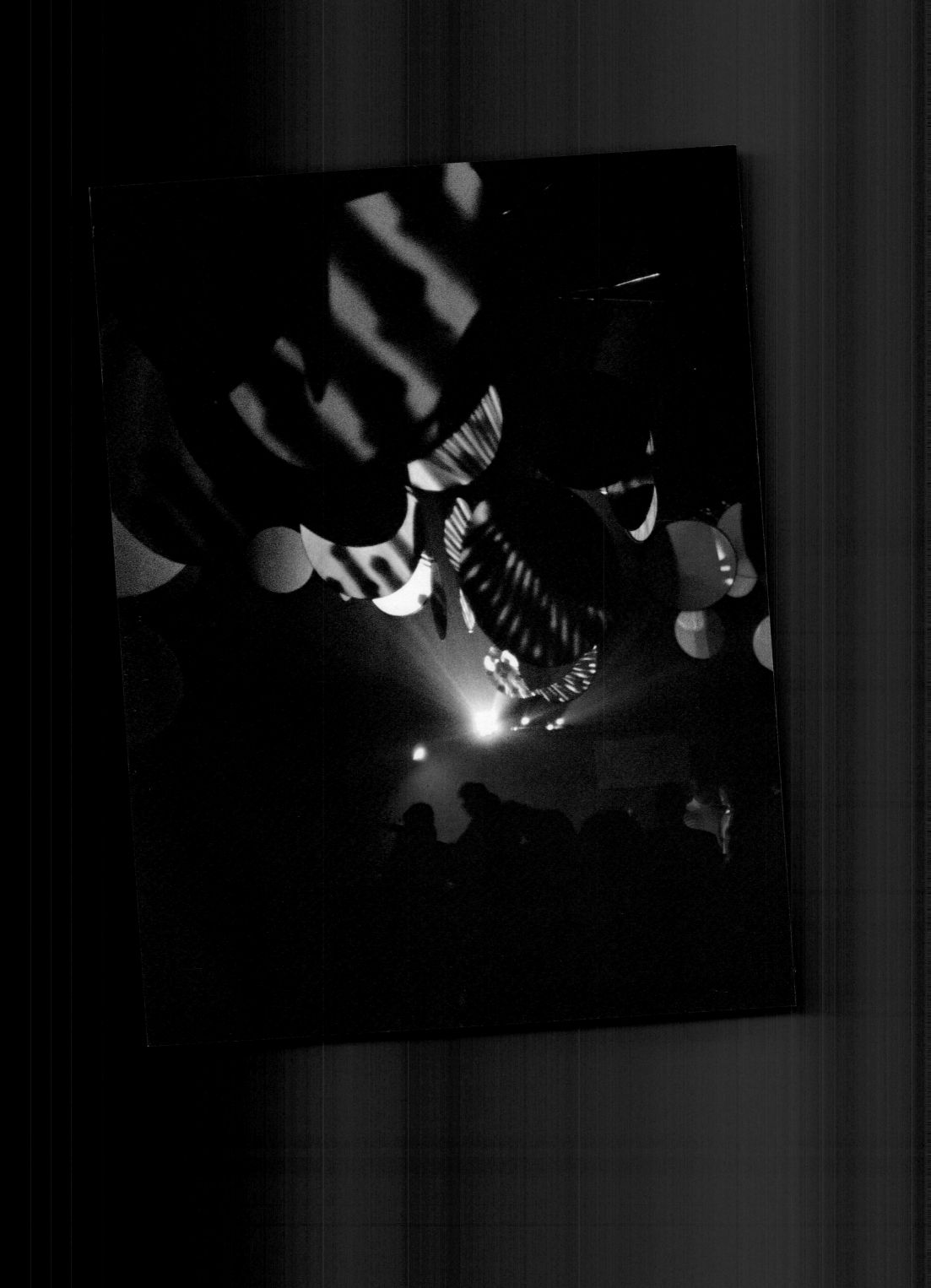

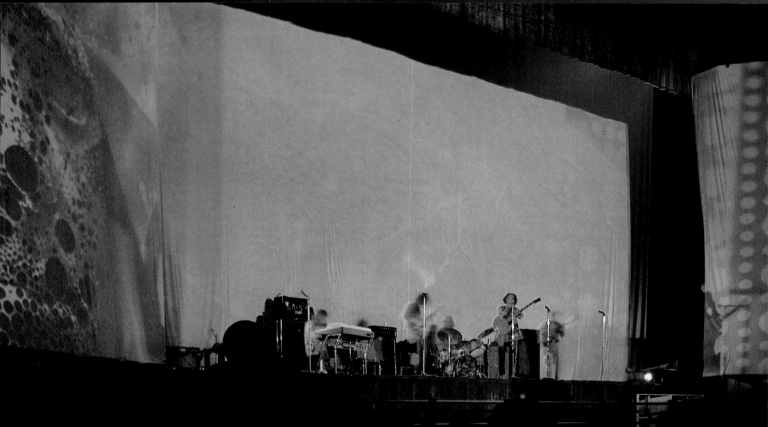

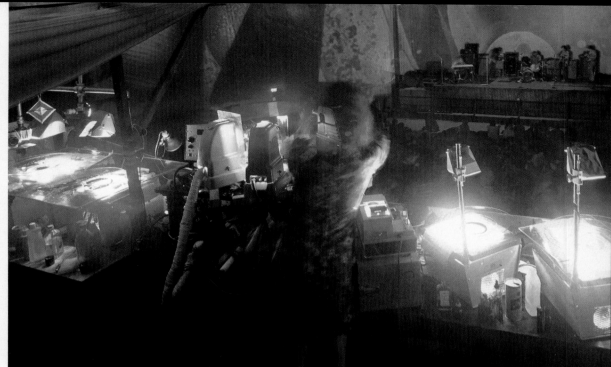

Left: A rock concert at the Avalon Ballroom, San Francisco. Above and below: Psychedelic light show projectors. Right: Psychedelic light show slide.

OVERLEAF. Left and top right: The Grateful Dead at the Pacific Cliffs, California. Below right: The Grateful Dead in concert.

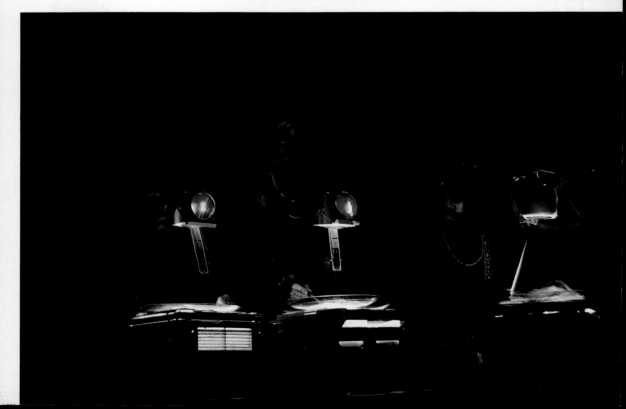

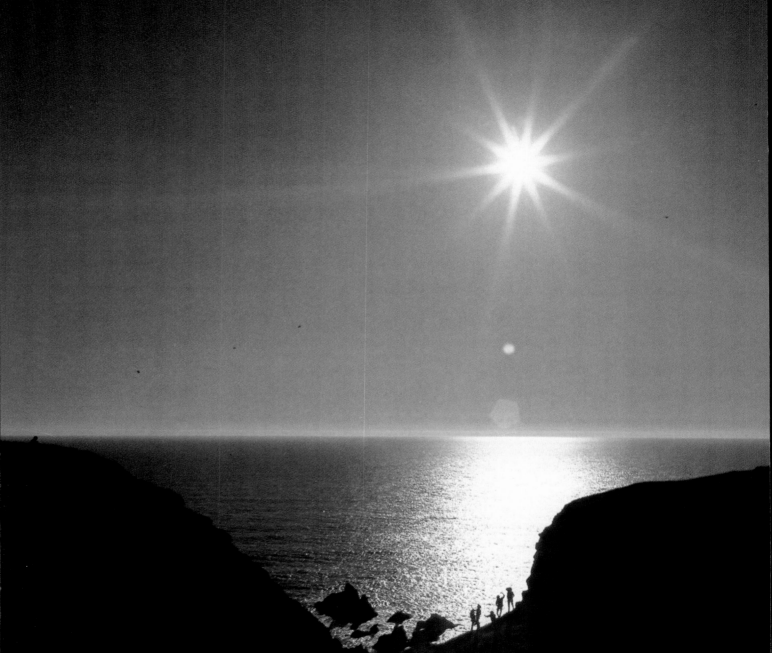

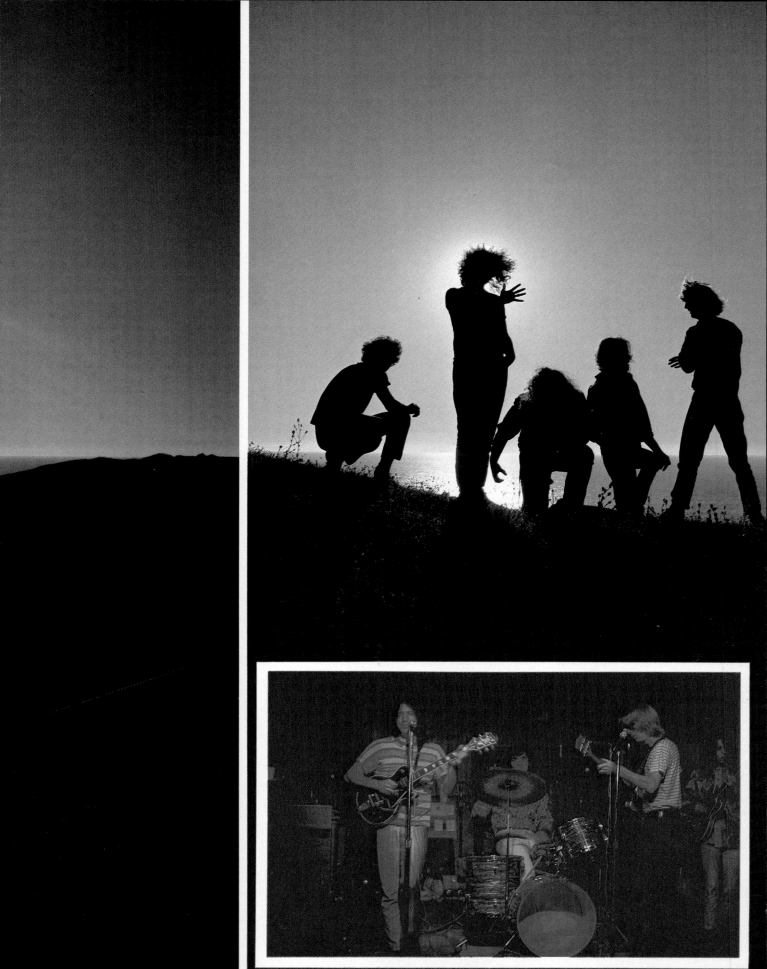

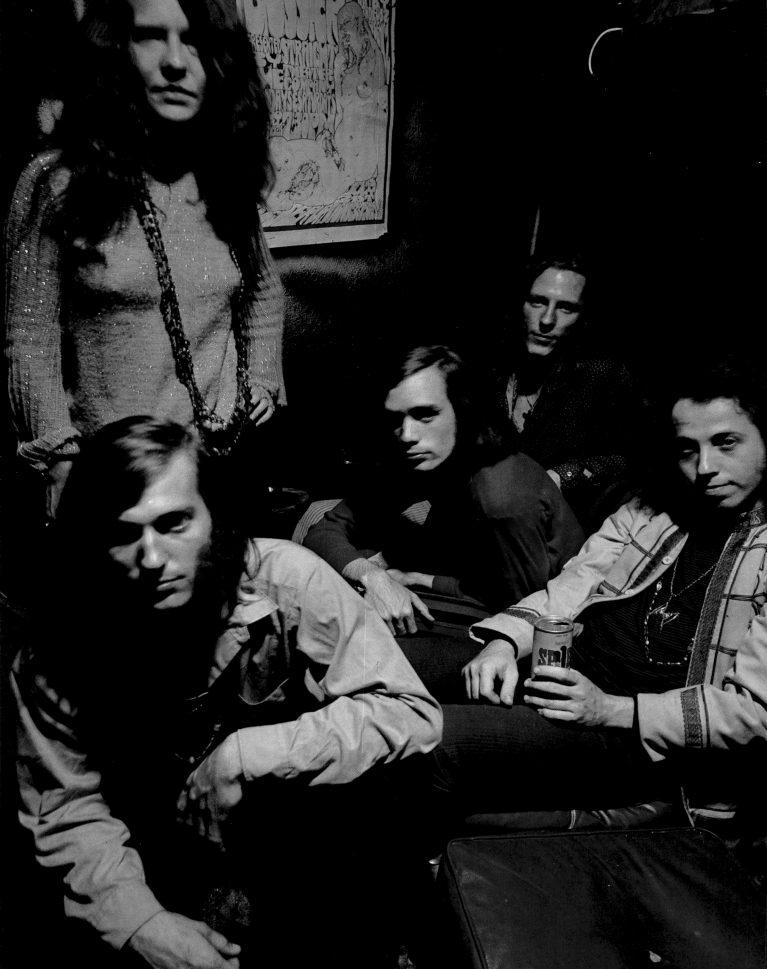

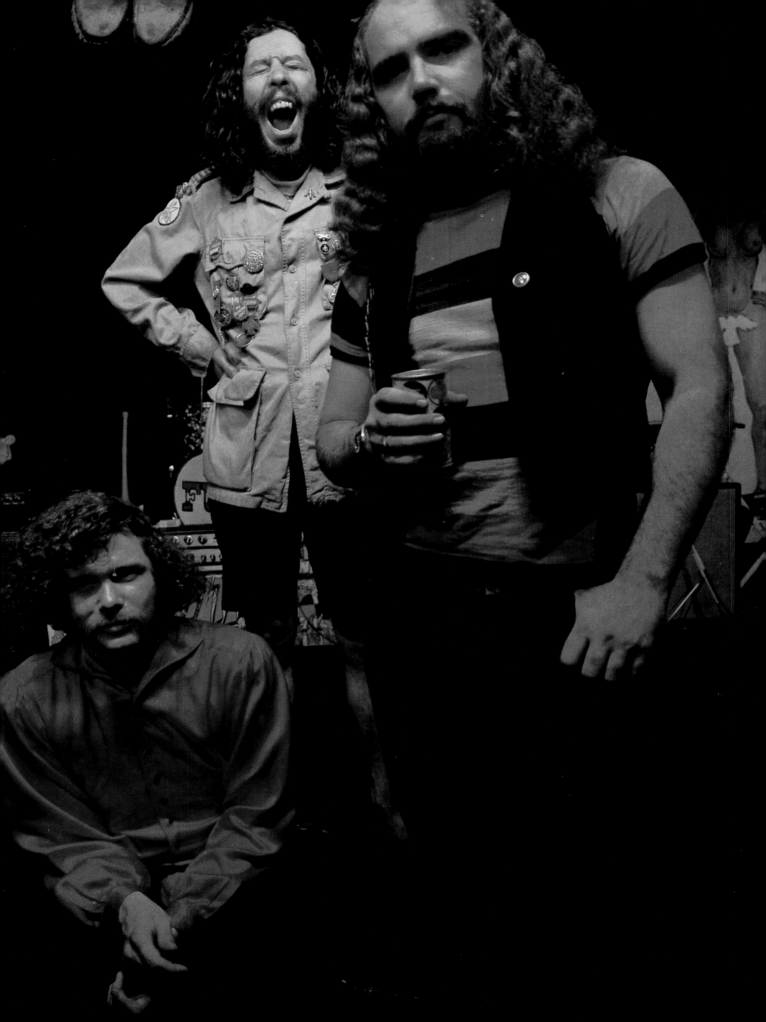

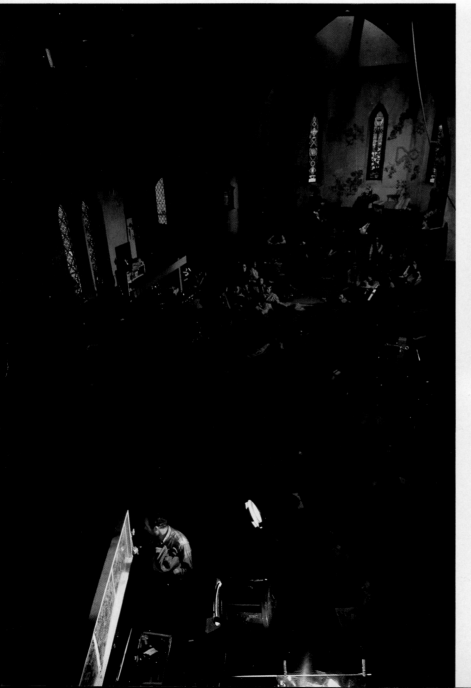
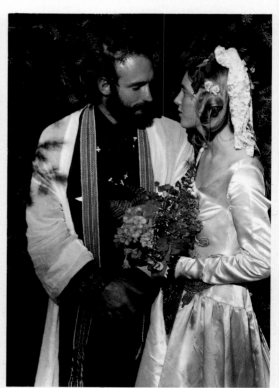

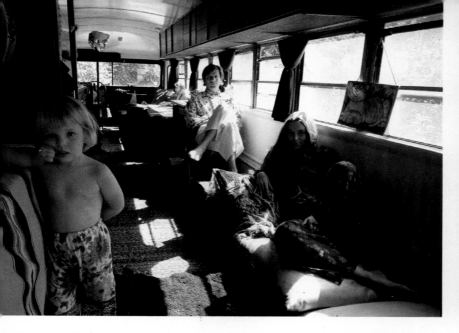

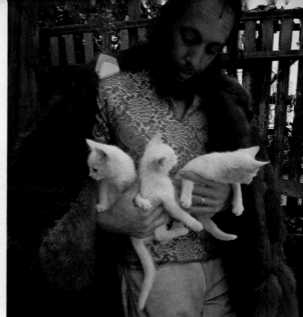

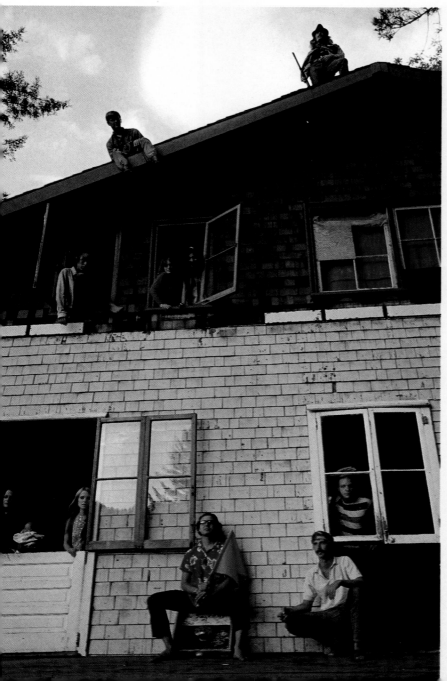

This page. Top left: Joel Kramer, yoga master, and his family in their bus. Top right: Roger Chilton of the Family Dog Commune, San Francisco. Left: C.I.A. (Citizens for Interplanetary Activities) Rock Commune, California.

Opposite. Top left: Alice of "Alice's Restaurant.".Top right: Wedding of Arlo and Jackie Guthrie. Lower left: Film production of *Alice's Restaurant* in church in the Berkshires. Center right: A hippie wedding in San Francisco. Lower right: Ray Brock, of the Trinity Motorcycle Club.

PRECEDING PAGES. Left: Janis Joplin and rock band Big Brother and the Holding Company backstage at the Fillmore, San Francisco. Right: The Fugs. From left to right: Ed Sanders, Tuli Kupferberg, and Ken Weaver.

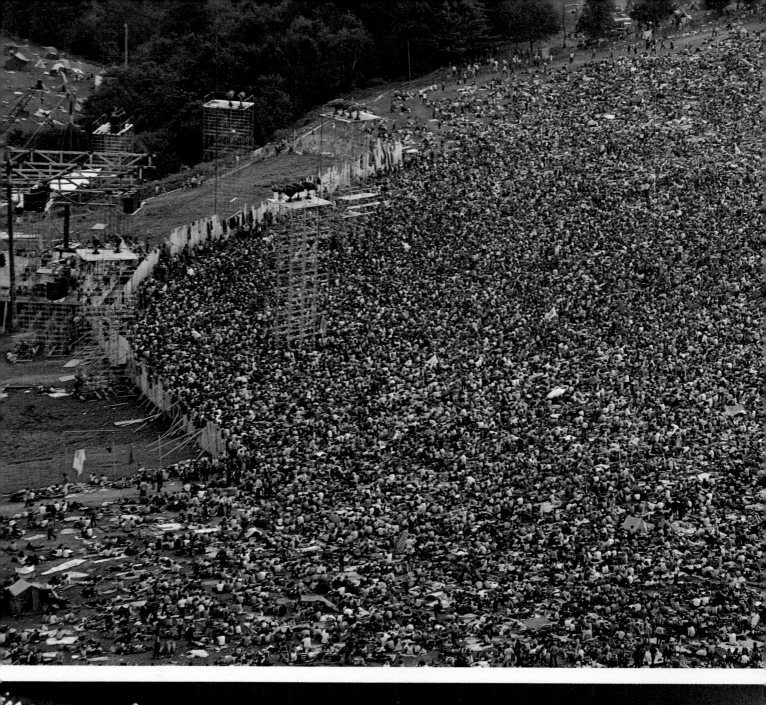
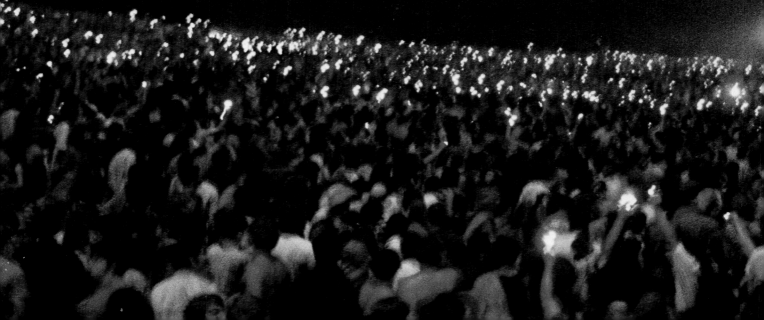

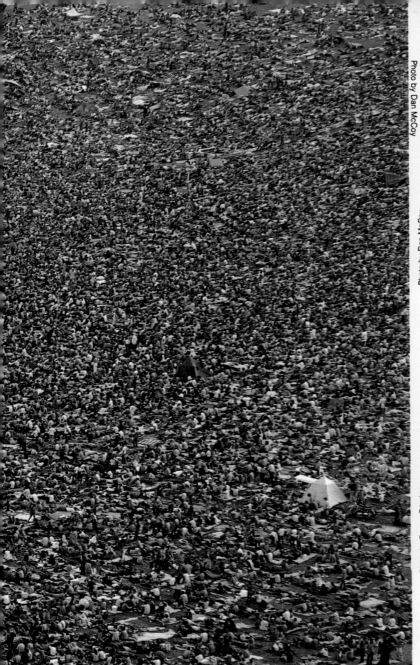

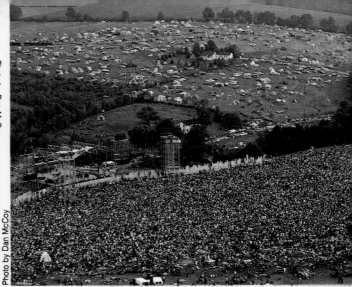

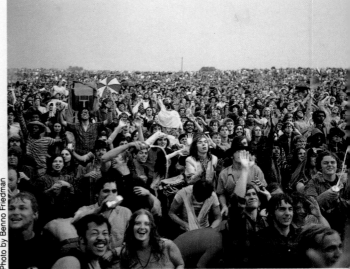

Woodstock, New York.

OVERLEAF. Left: Kit Lasceaux, Joe McCord, and Doug Campbell at the Quarry, the Berkshires, Massachusetts. *Time is pressed on the face of the rocks.* Right: Rock band The Magic Powerhouse of Oz, San Francisco.

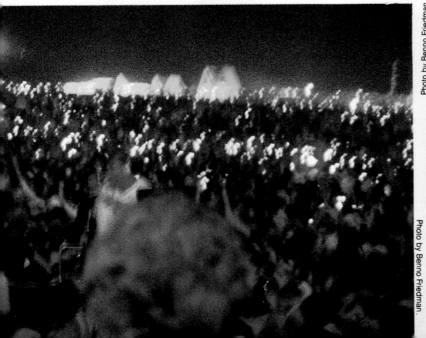

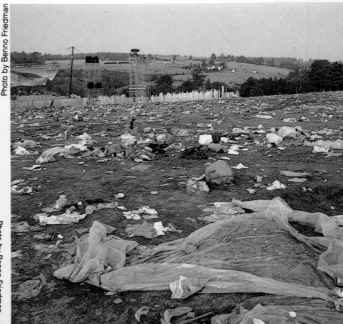

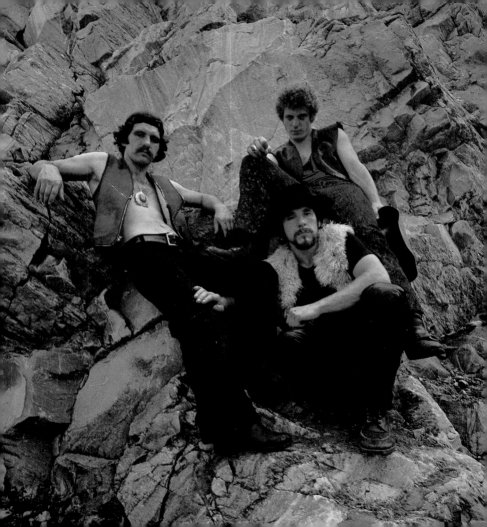

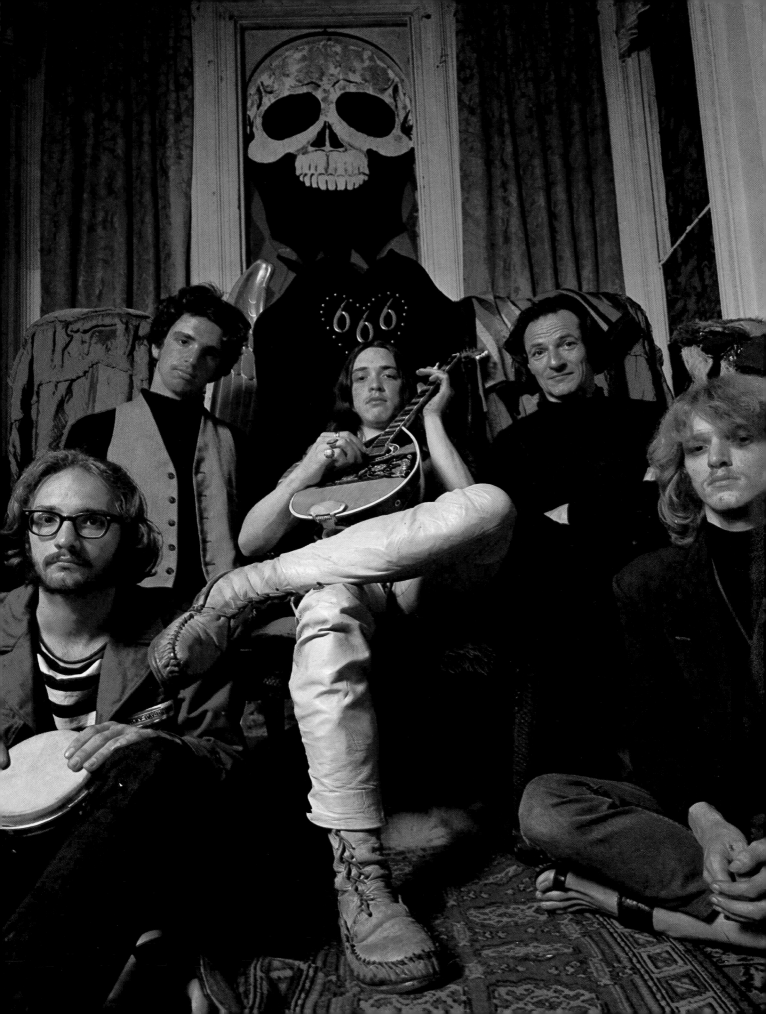

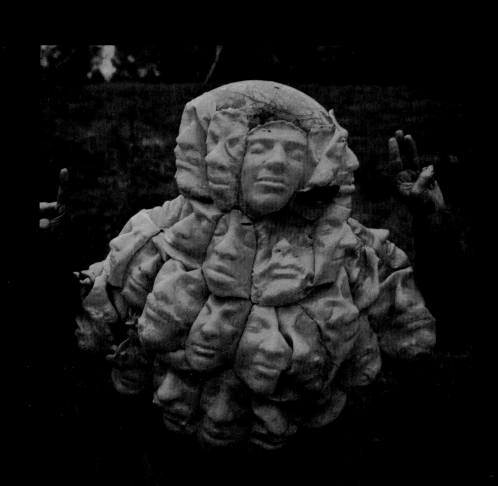

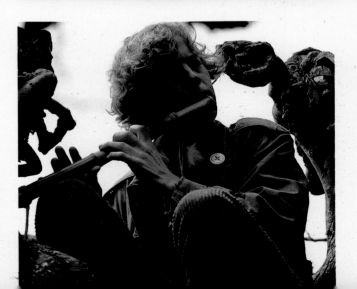

Left: California flower children, "Summer of Love."
Opposite: Dr. Gunther Weil, the Berkshires, Massachusetts.

PRECEDING PAGE. Life masks of the Castalia Foundation
Community, made by Gray Henry, Millbrook.

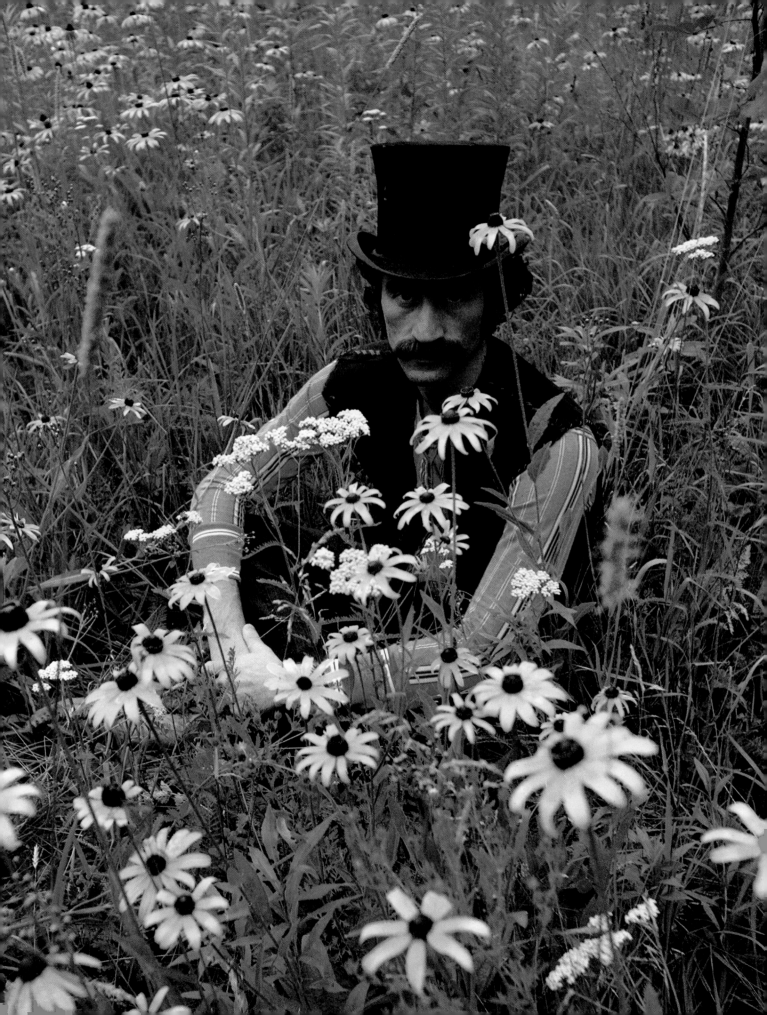

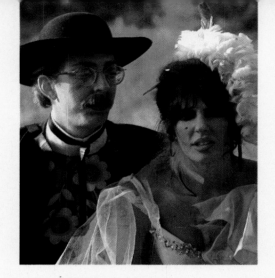

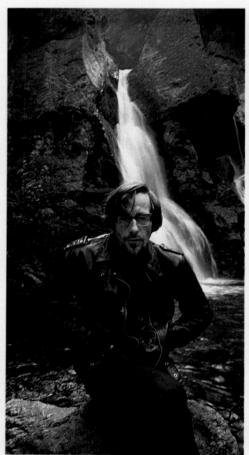

Above: Lou Gottlieb, founder of
Morning Star, in California, the first free
commune in the U.S.A. Center: Angus
MacLise, poet and mystic voyager,
Bash Bish Falls, the Berkshires,
Massachusetts. The rest: Hippies,
East and West.

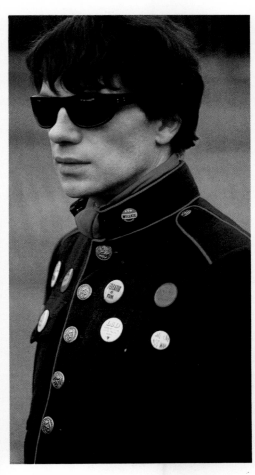

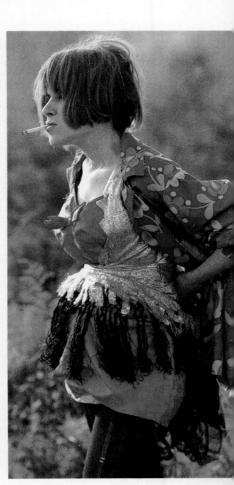

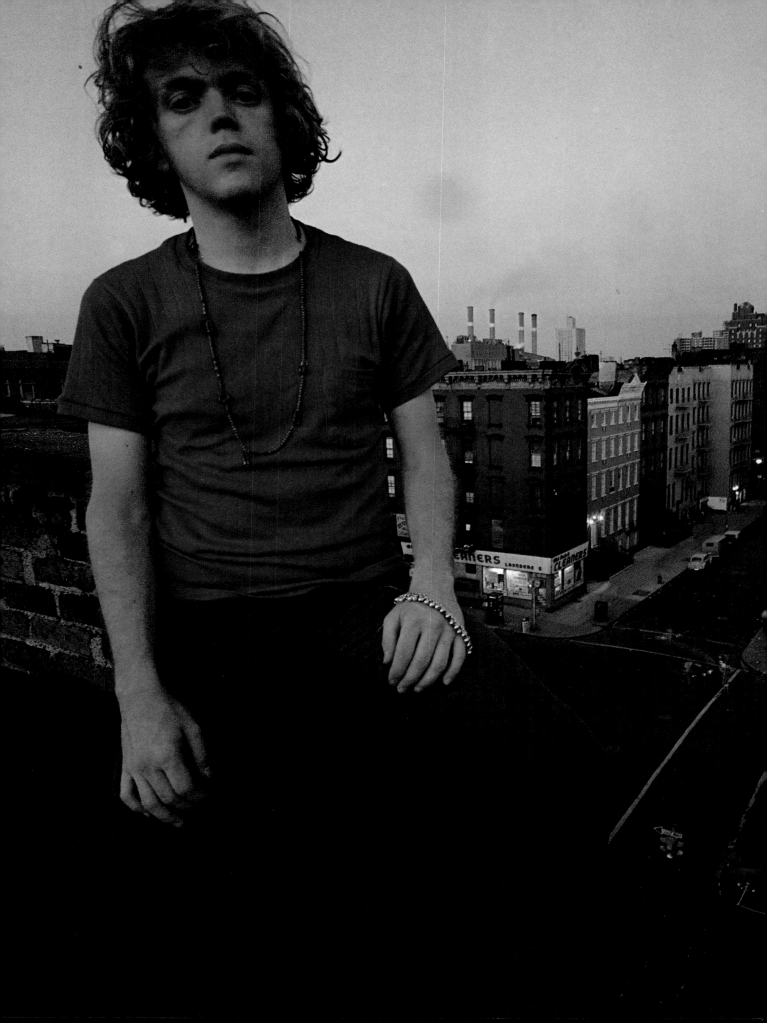

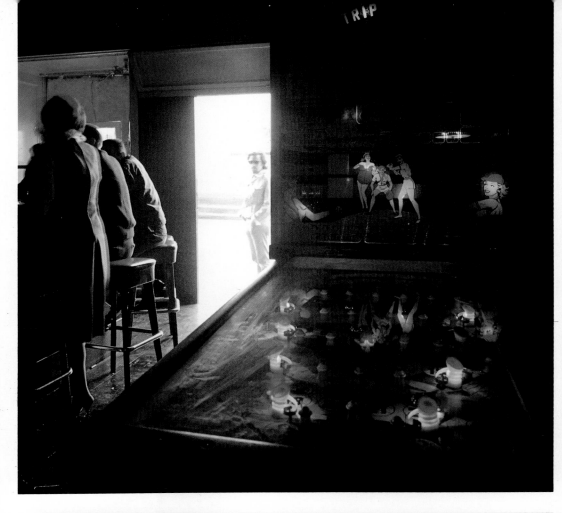

Opposite: Jim Fourat with "All-American" Con Ed stacks in background, Lower East Side, New York City. Upper left: Bar in Haight-Ashbury with all-woman baseball pinball machine and film-maker Steve Ashton looking in. Below: Abbie Hoffman.

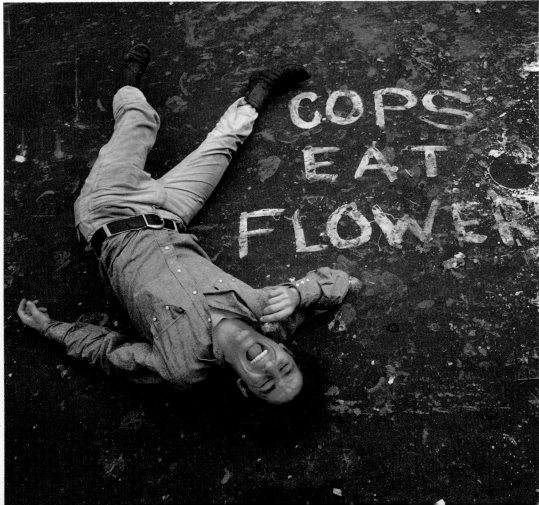

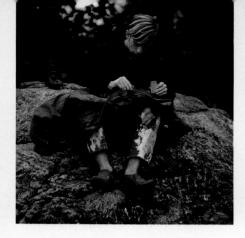

Above: California hippies. Below: Audience at a rock concert, Mt. Tamalpais, California.

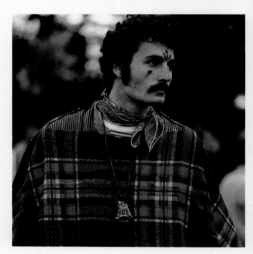

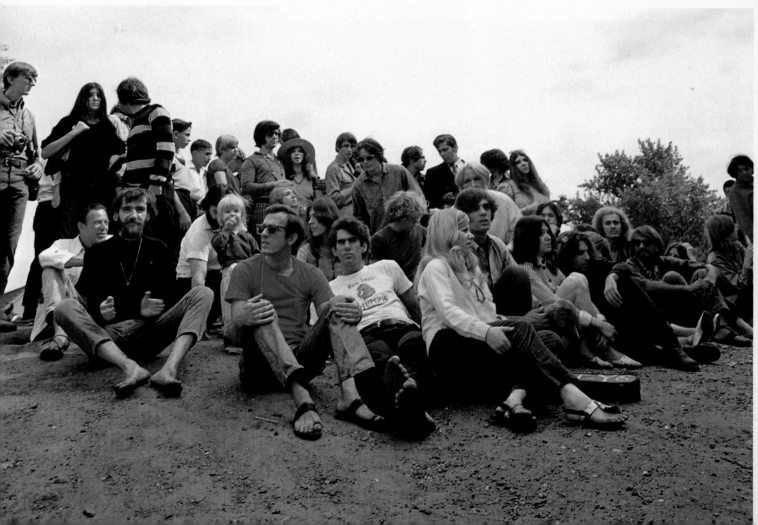

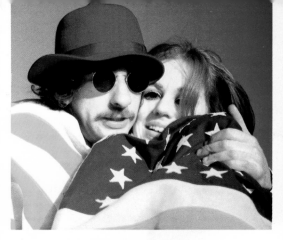
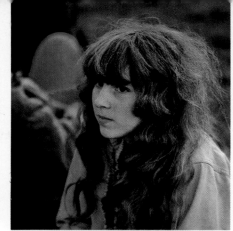
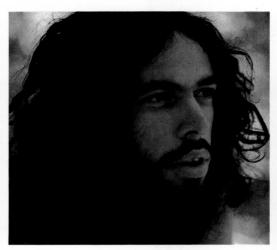
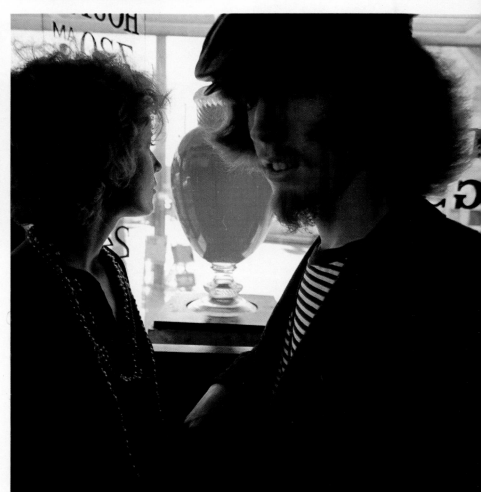

California and New York Love Generation.
Lower right corner: Abbie Hoffman burning
money.

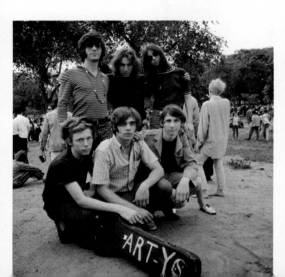

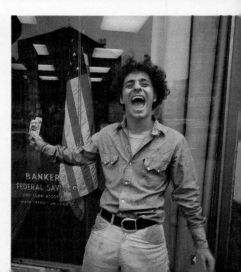

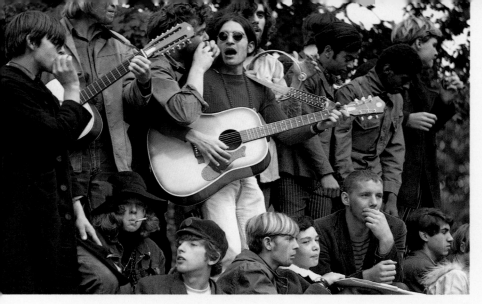

Top right and left: The first Earth Day Be-In, Central Park, New York City. Below left: Rock ecstasy in Golden Gate Park. Below right: Janis Joplin, with rock group Big Brother and the Holding Company, and the Fugs at a concert, in Golden Gate Park, San Francisco.

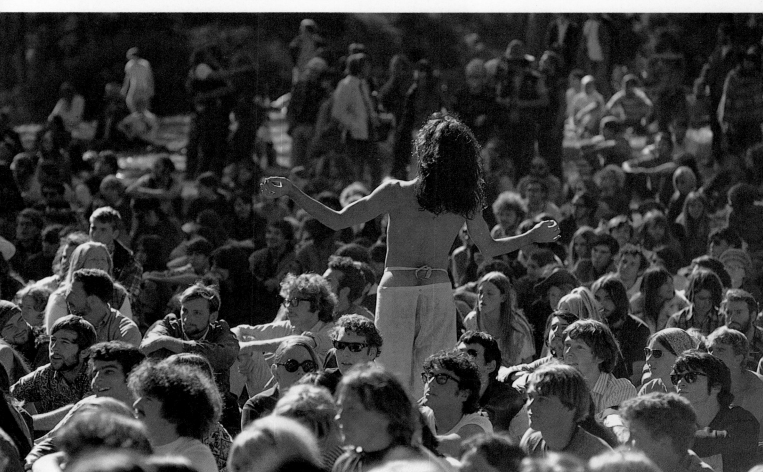

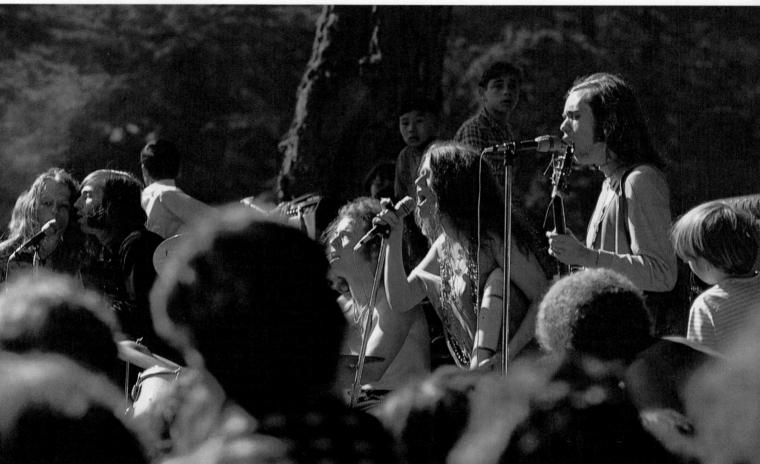

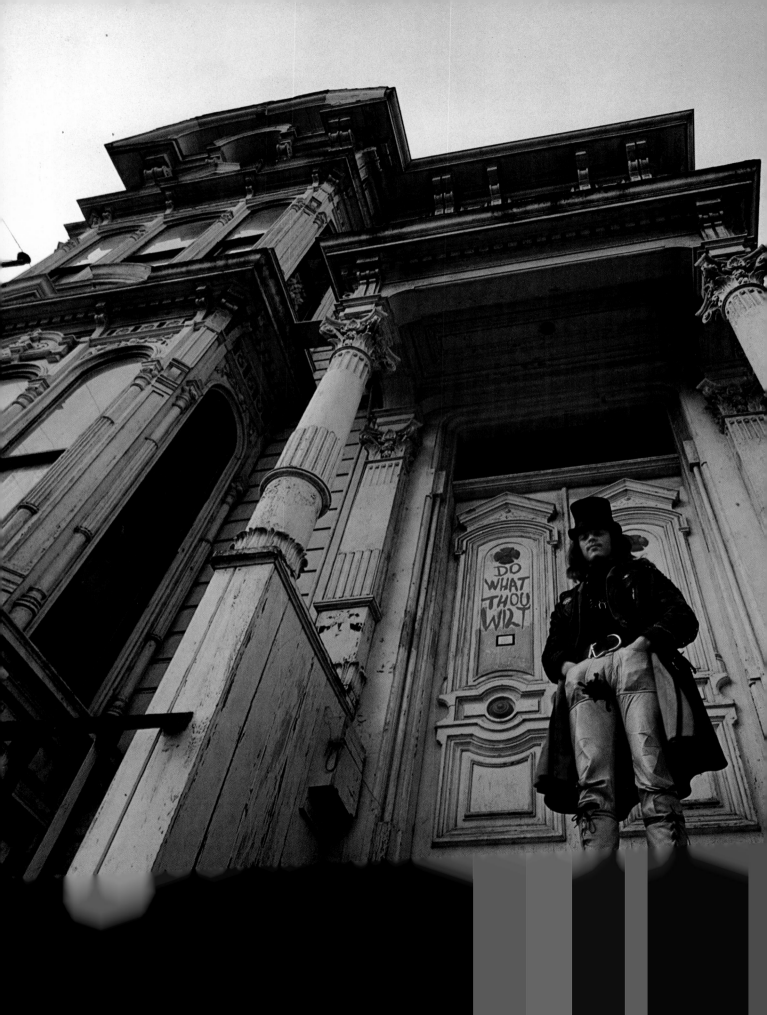

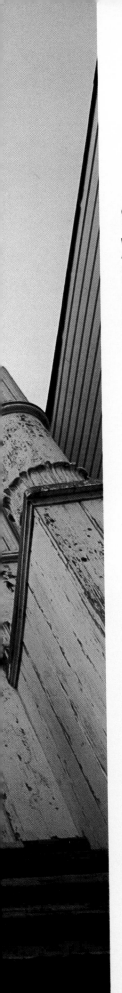

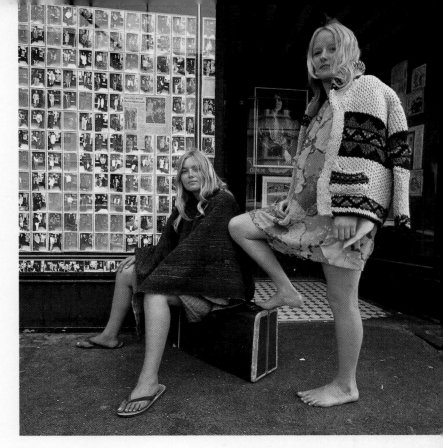

Opposite: Rock musician Bobby Beausoleil, San Francisco. *Do what thou wilt is the whole of the Law* —Aleister Crowley. Top and center right: New arrivals in Haight-Ashbury, San Francisco. Center left: Community bulletin board. Below: Haight-Ashbury hippie.

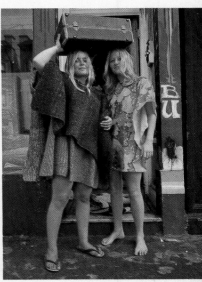

OVERLEAF: Far left: Film-maker Rick Patton in San Francisco. Upper left: Jonathan Chernoble, "student of silence," the Berkshires, Massachusetts. Upper right: Haight-Ashbury street magician. Lower left: Jack Smith, playing the part of Rose Courtyard in his film, *Flaming Creatures*. Lower right: "Sgt. Pepper" hippie.

SECOND OVERLEAF. Left: Portrait of Michaeleen Maher, the Berkshires, Massachusetts. Right: Marylyn Jean Krause at twilight on Long Island, New York.

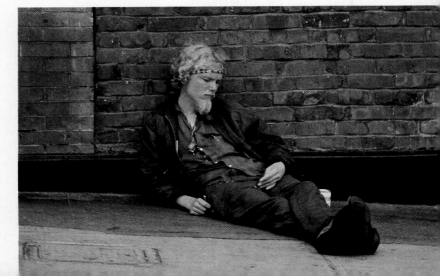

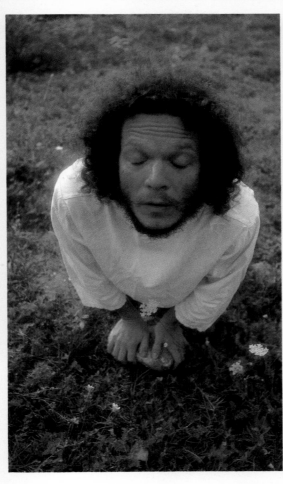
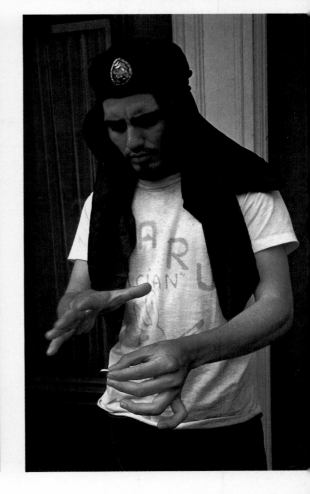
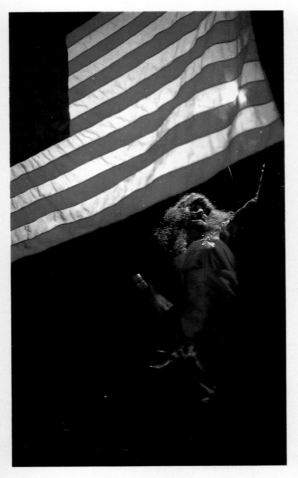

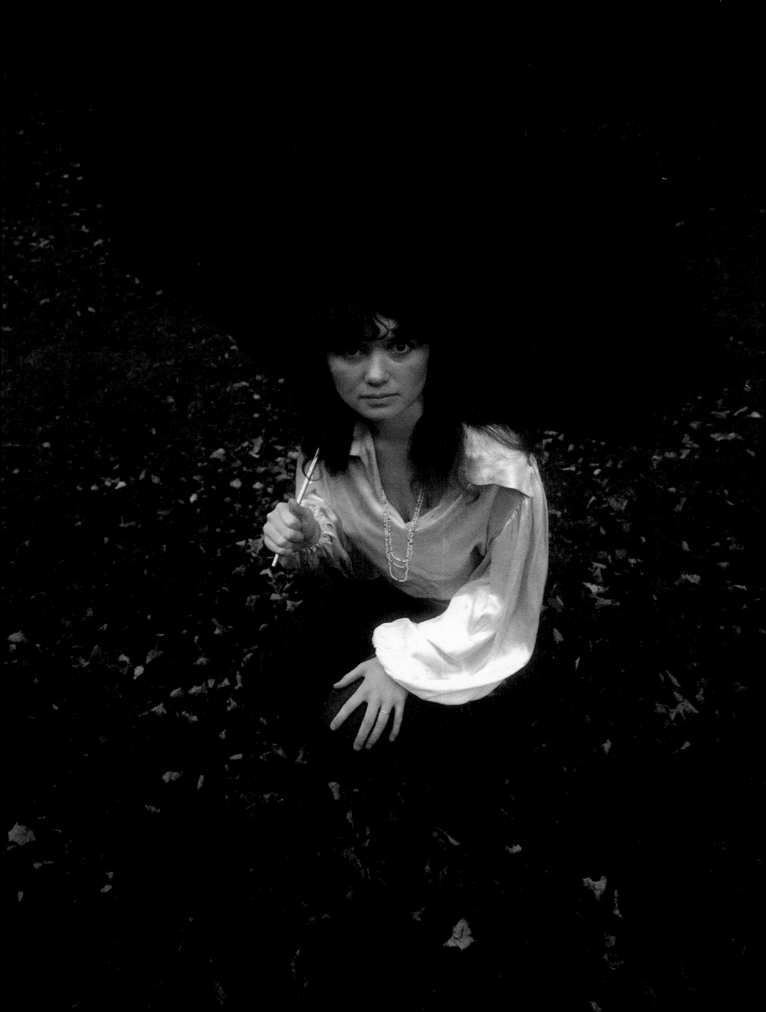

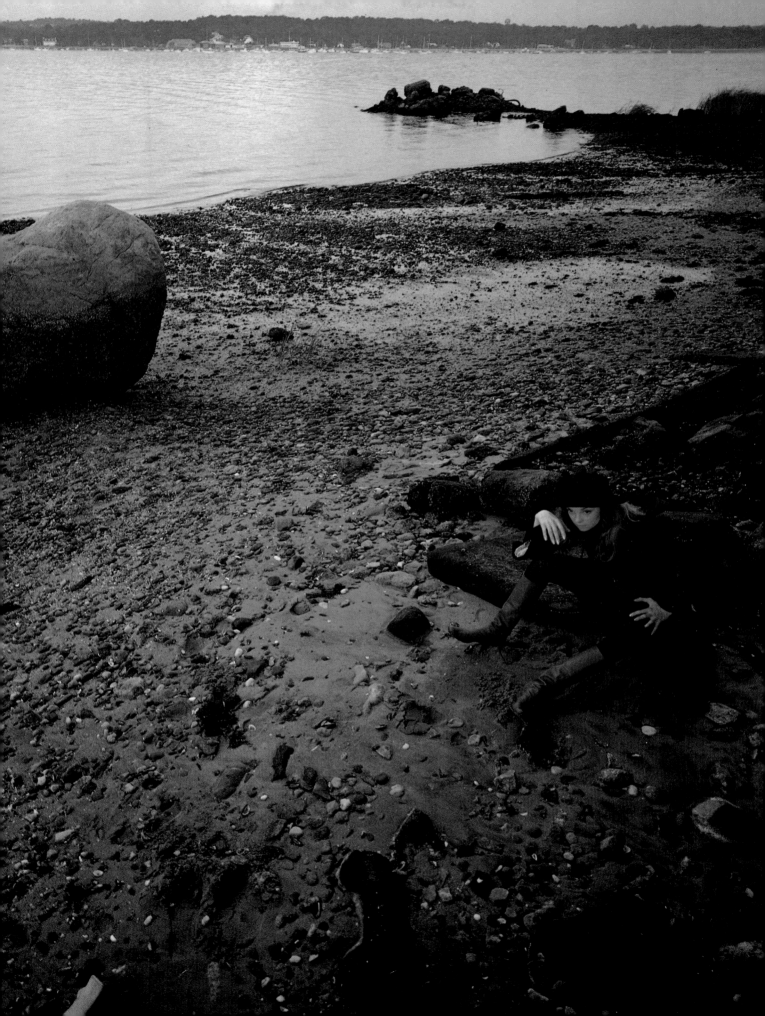

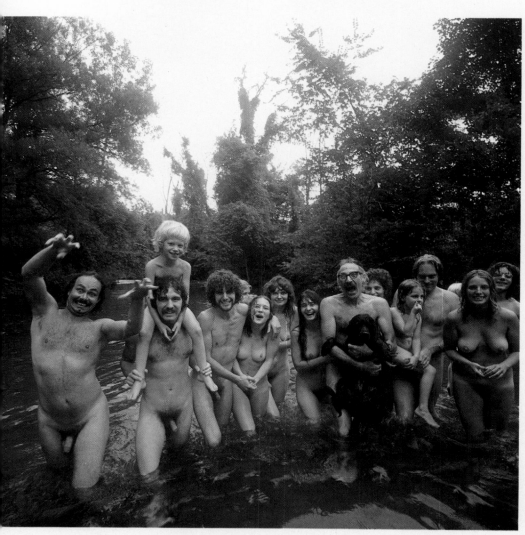

Above: Skinny-dipping in the Green River. Opposite: Hilary Harris, film-maker; his painter wife, Maxine, their children, and the Rockwell children. The Berkshires, Massachusetts.

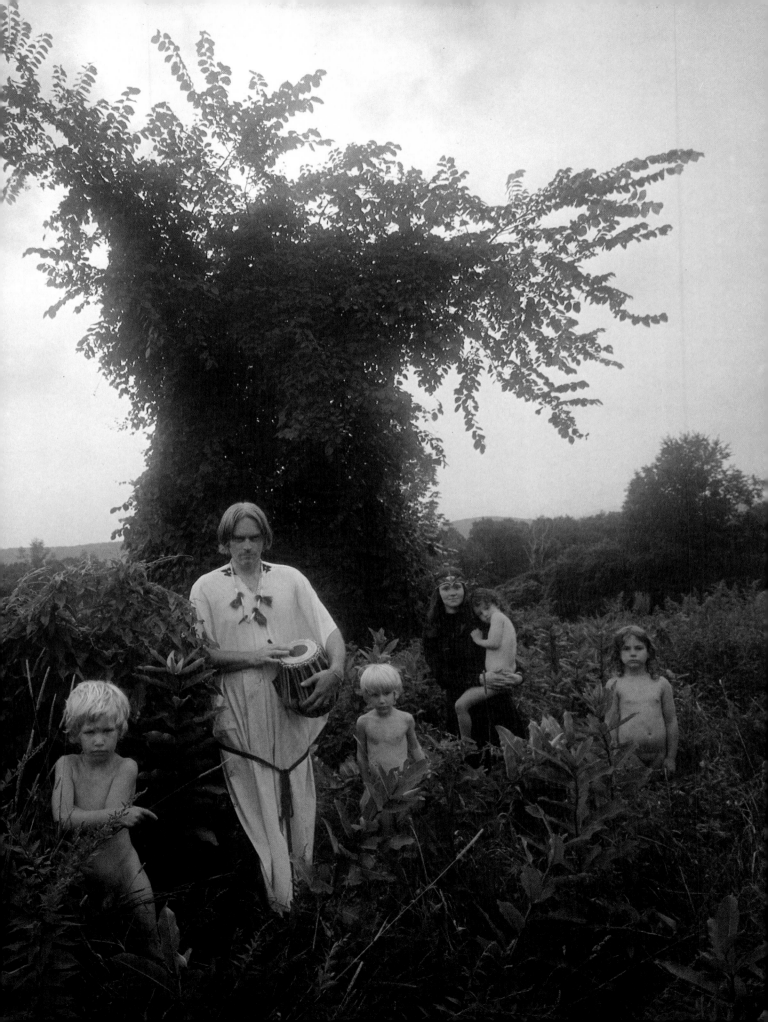

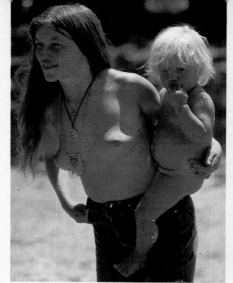

"Children of the children."

OVERLEAF. Hell's Angels at the funeral of "Chocolate George," San Francisco.

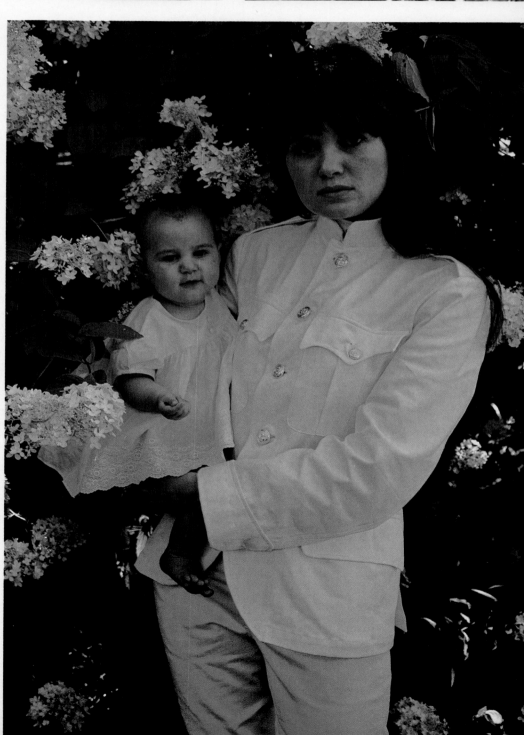

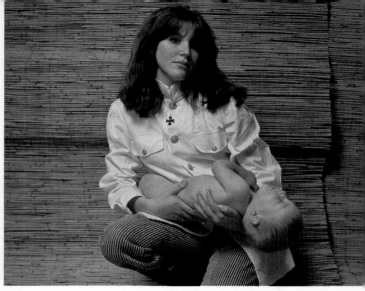
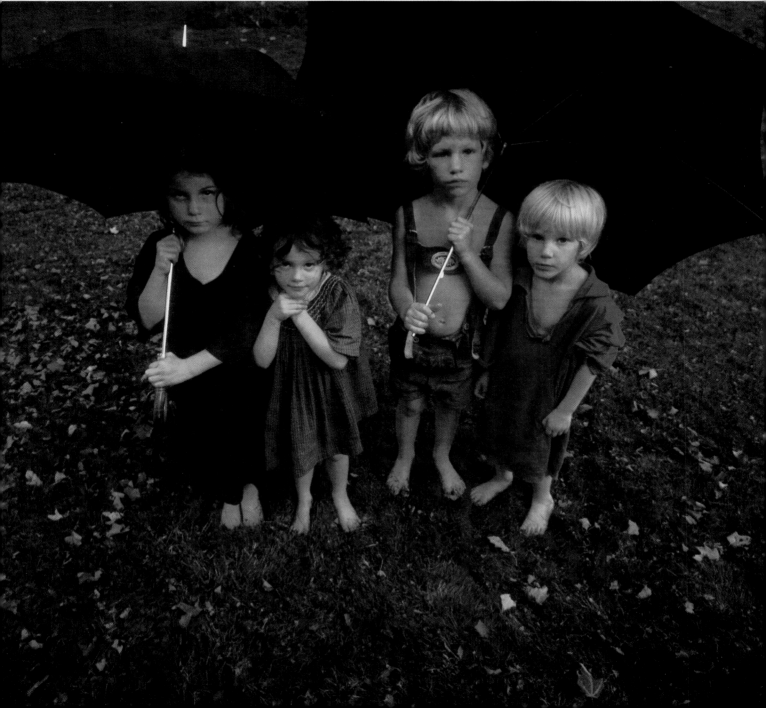

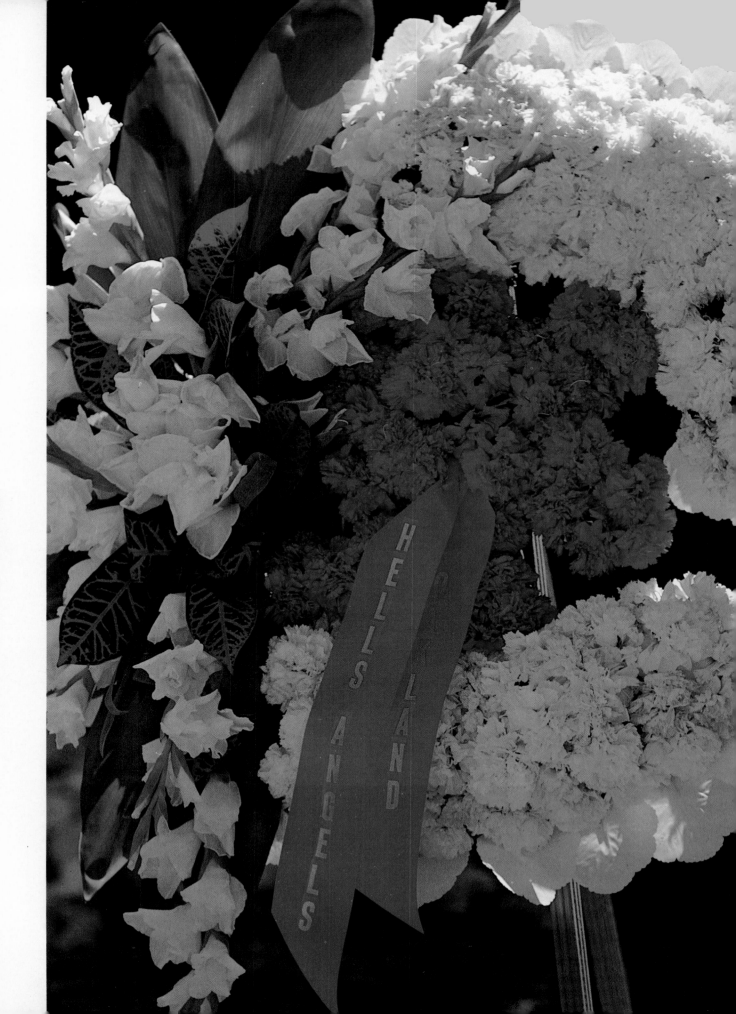

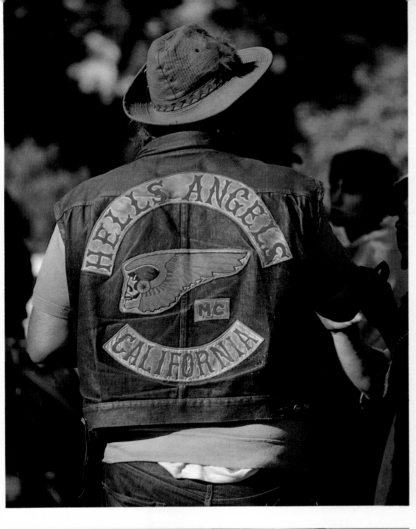
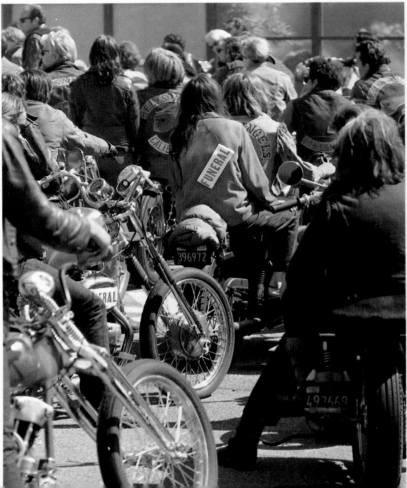
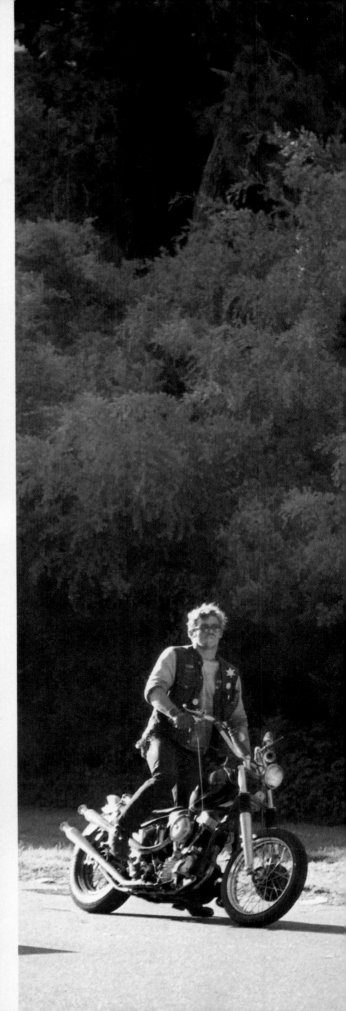

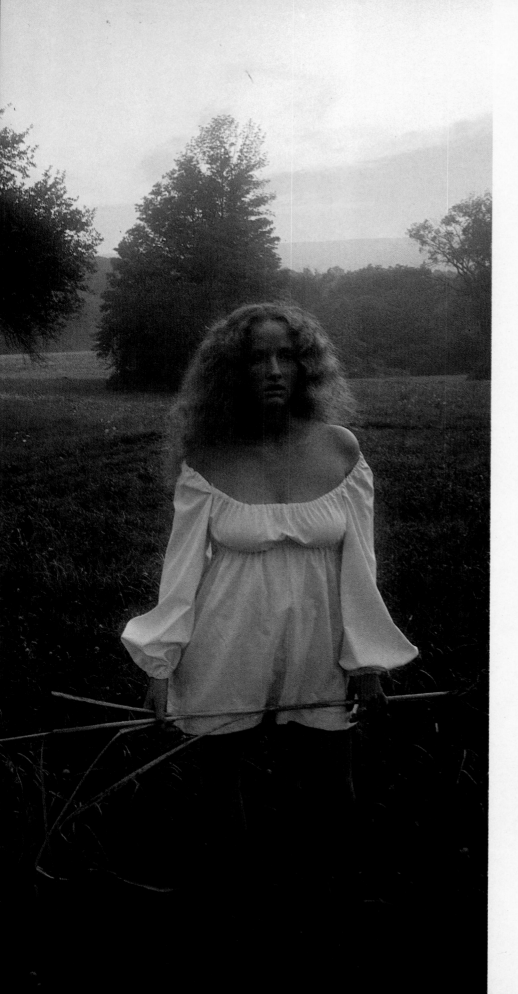

Left: Kathie McNeil, the Berkshires, Massachusetts. Right: Wanderer on a Connecticut road.

OVERLEAF. Left: Herbalists Ann Carter and Ann McCord. Upper right: Michael McClanathan, actor and poet, and Raine. Lower right: Woodsman Victor Robbins. The Berkshires, Massachusetts.

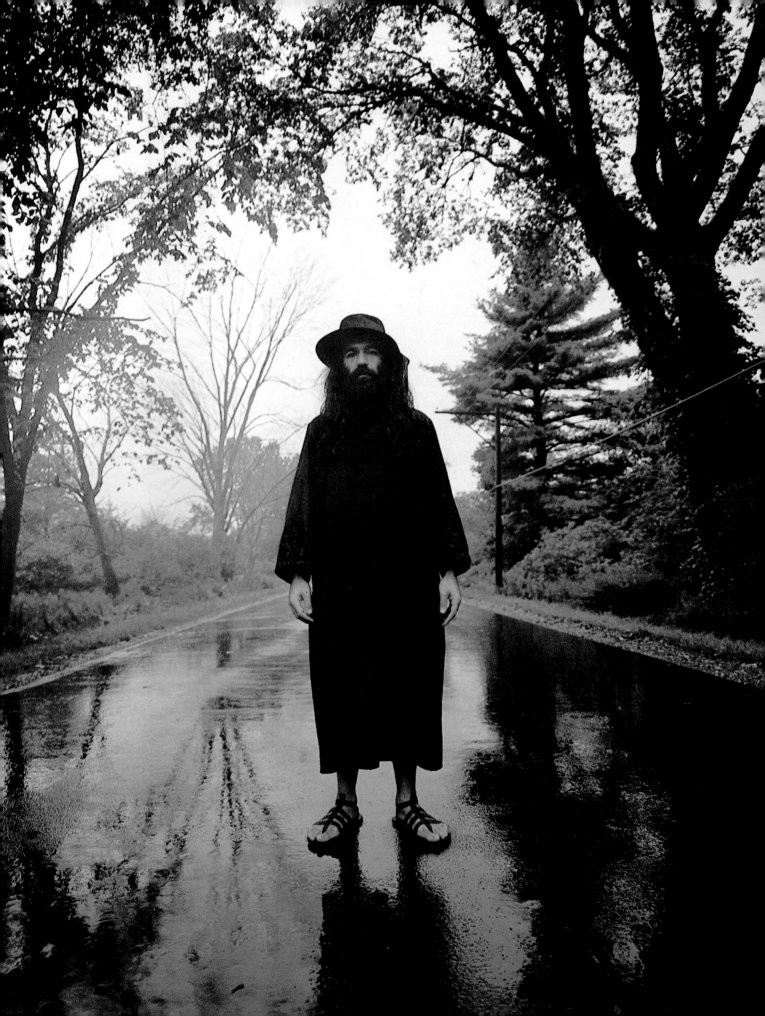

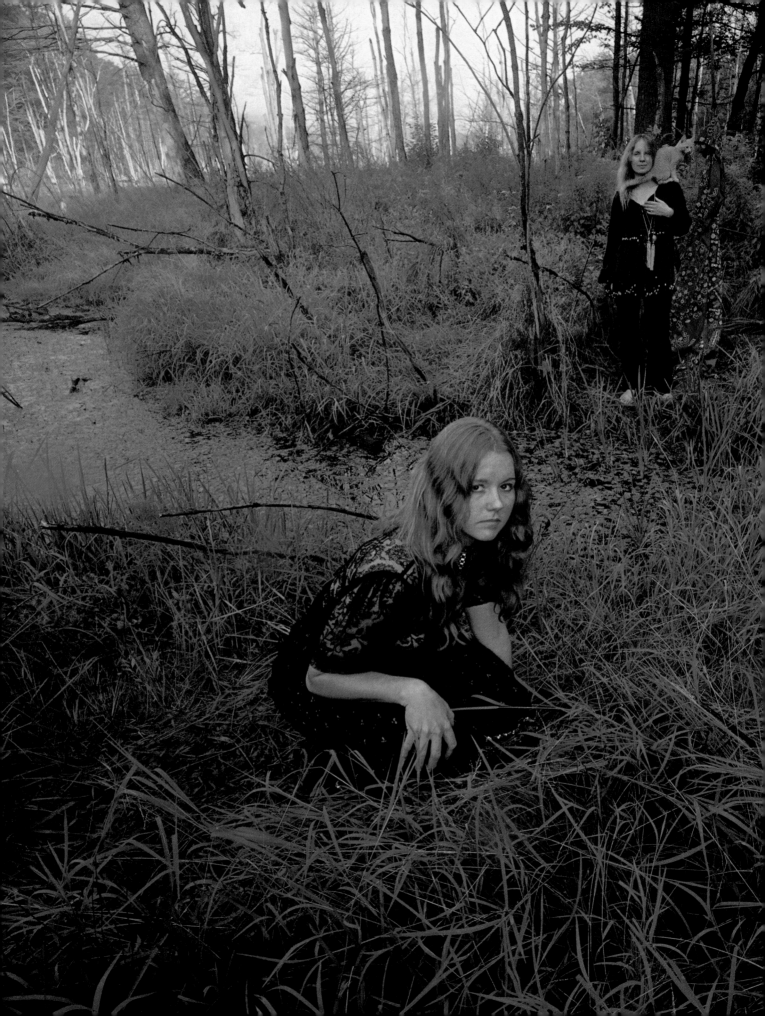

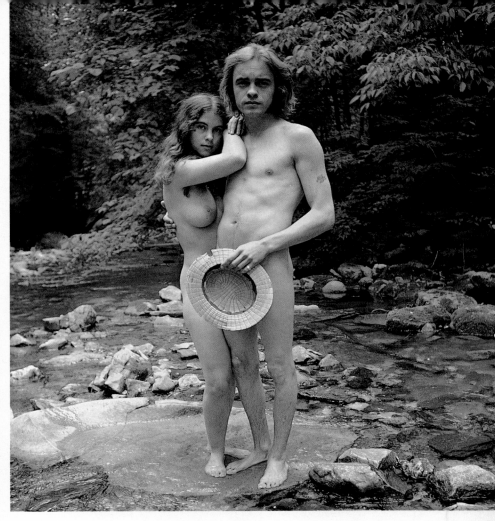
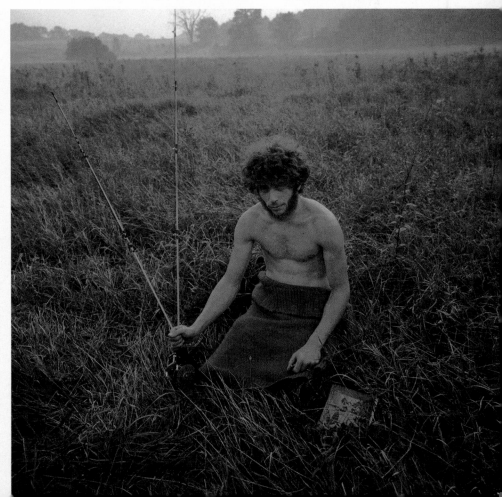

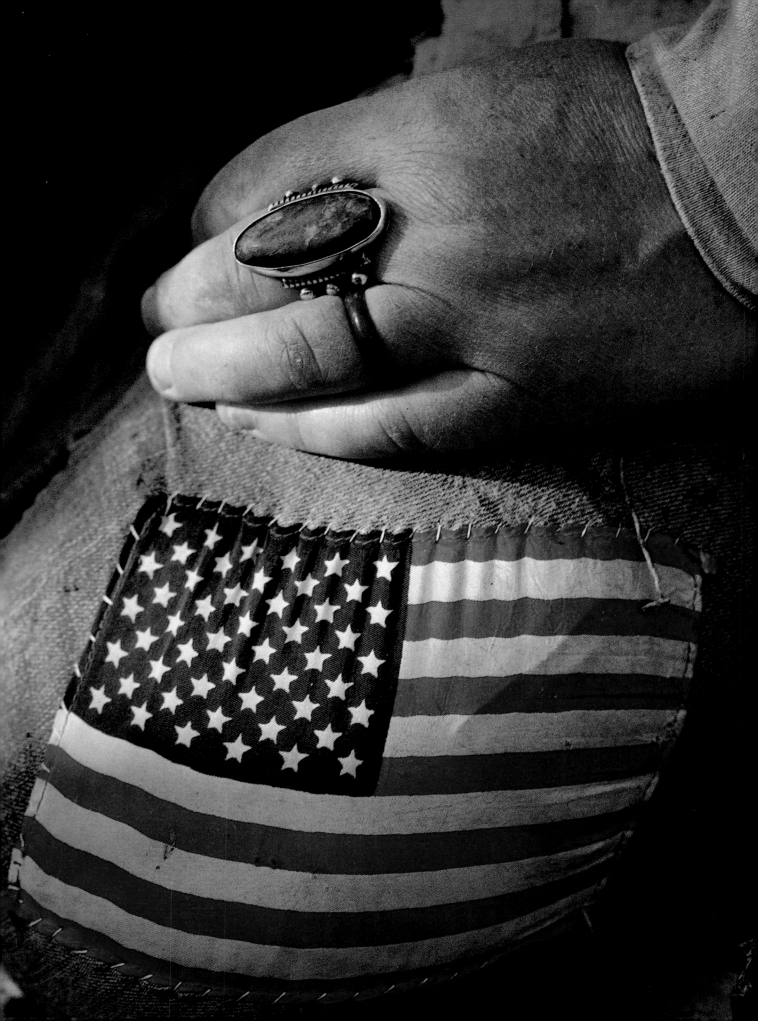

Top left: Rolling an invisible joint. Bottom left: Back of Wavy Gravy of the Merry Pranksters, and the Hog Farm. Bottom Right: Poet Gerard Malanga.

OVERLEAF. Left: "Auto-collage." Actresses Hollis and Holly, mother and daughter, at a California scrap-metal yard. Right: Dr. Ralph Metzner, psychologist, editor, and cofounder of the Castalia Foundation, in California.

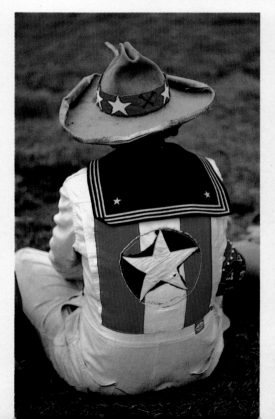

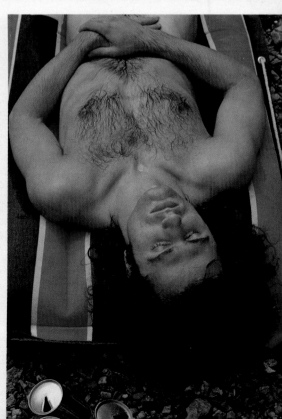

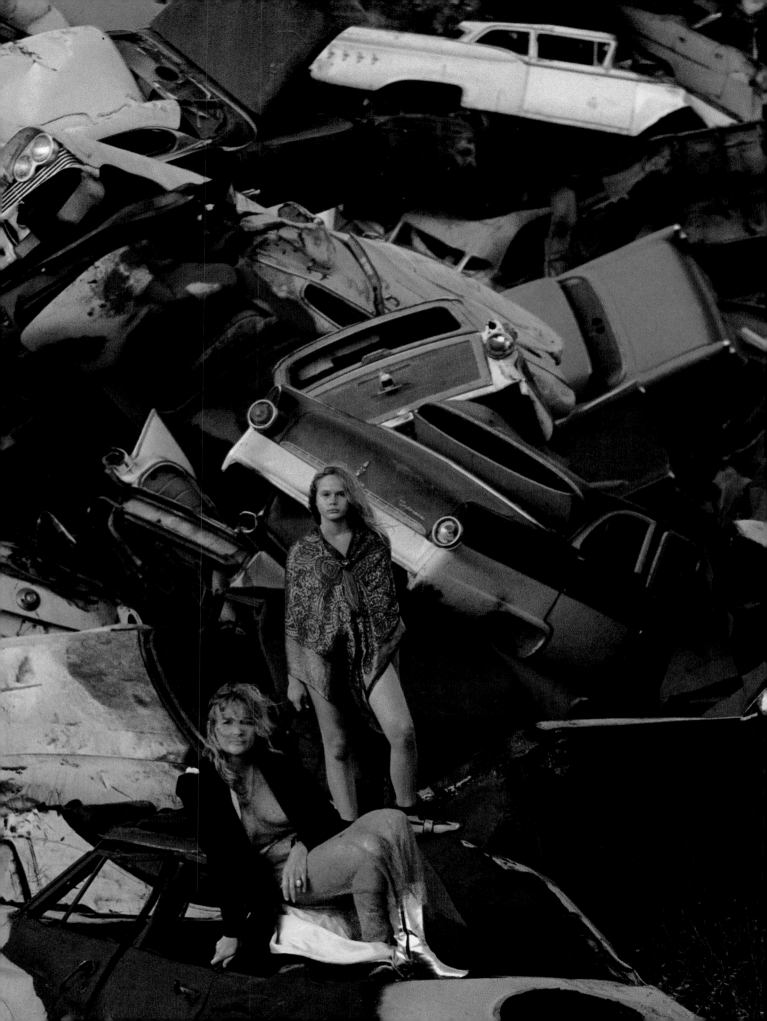

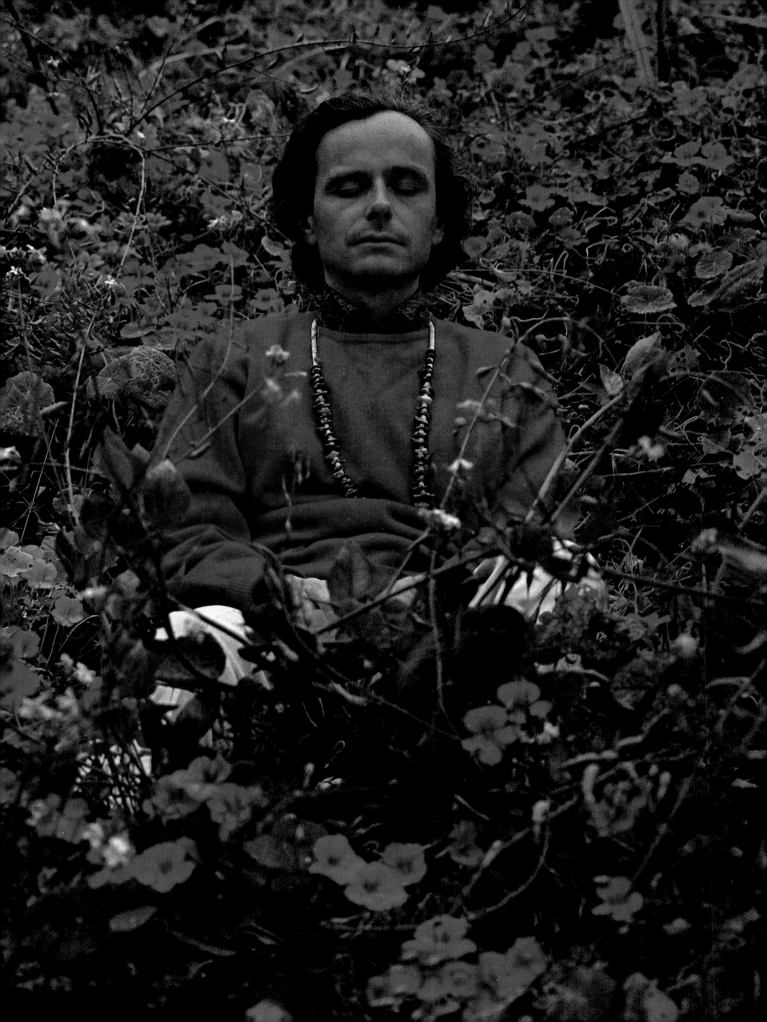

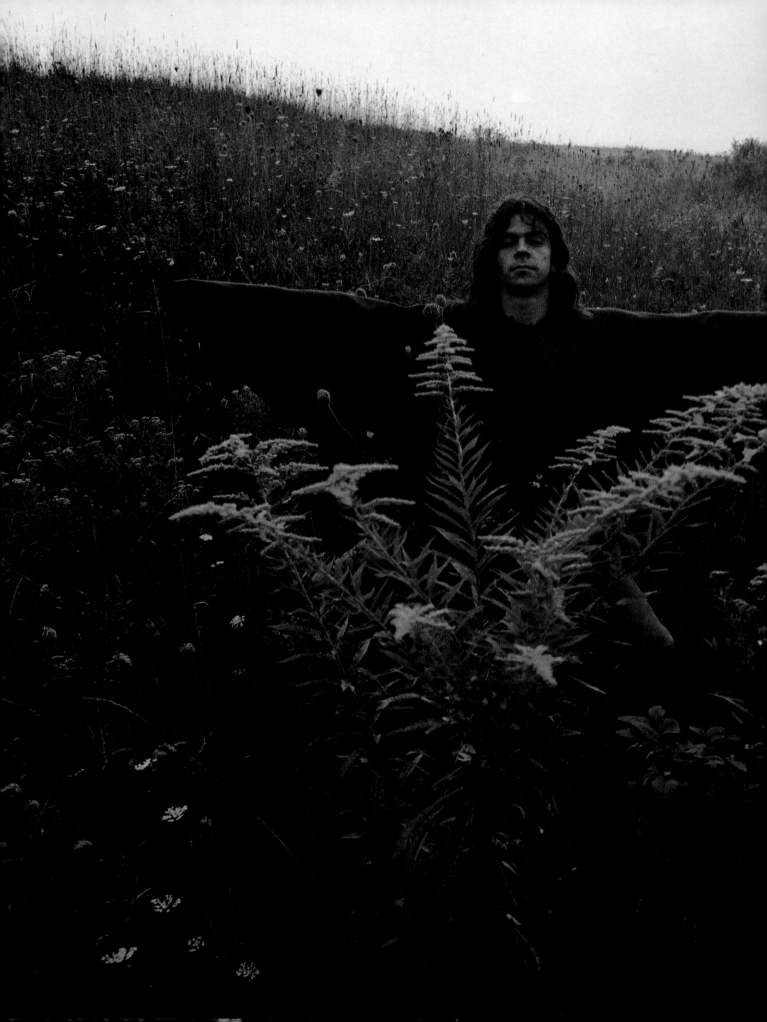

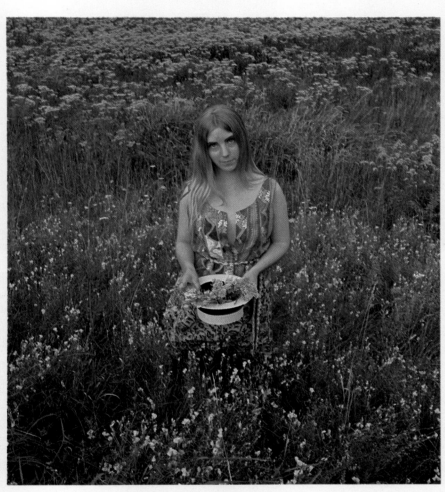

Left: Ben Schawinsky, carpenter, sculptor, and flautist. Above: Eileen Levy, fashion designer.

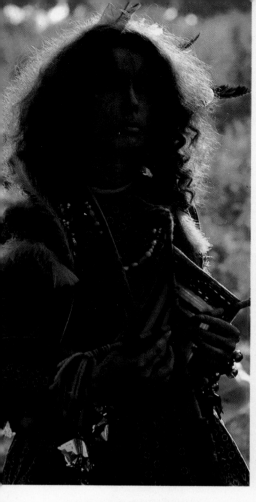

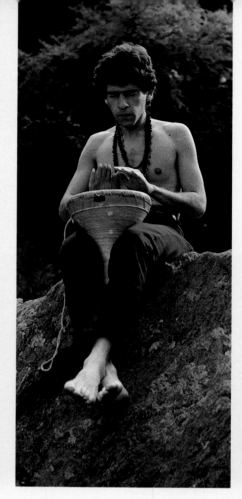

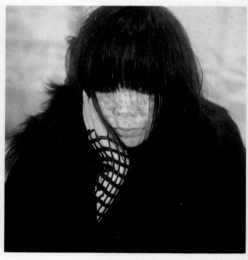

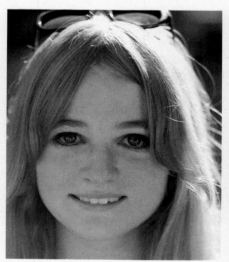

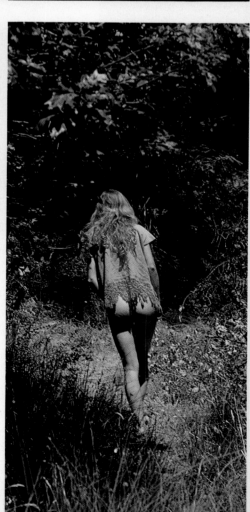

"Children of the era." Upper left corner: Actress Ultra Violet. Center upper right: The late Charles Mingus, jazz musician, as a psychedelic *bandito*.

OVERLEAF. Dancer Erica Robbins, in front of a tombstone which might be that of her Salem ancestor.

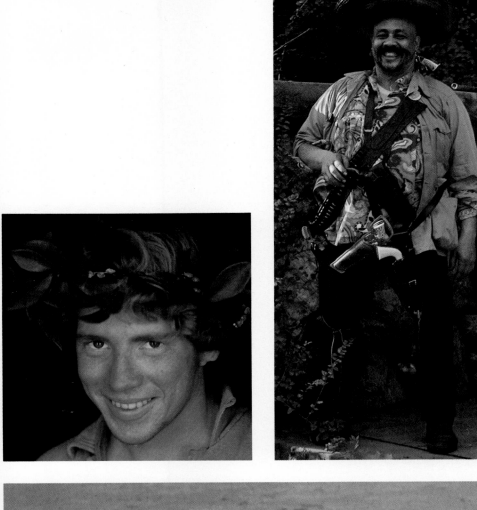

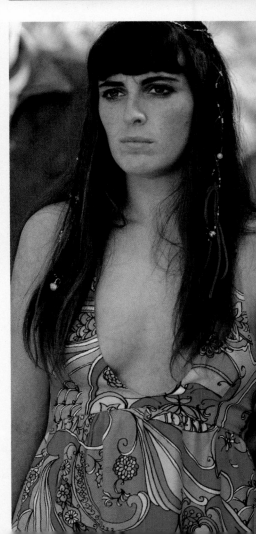

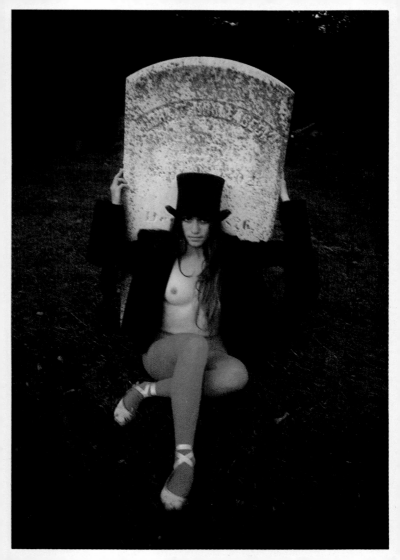

ACKNOWLEDGMENTS

First of all, to my wife, the inimitable Michaeleen, aka Mikki, stalwart traveling companion and photographic collaborator on what became our odyssey. Steve Ashton, filmmaker, photographer, friend, and guide. Charles Mee, Jr., for the encouraging support and foresight, Joseph Thorndike, Sherman Parsons, and the staff of *Horizon* magazine, who helped make this color photography possible.

Gomathi, aka Carol Ann Remmert Byrne, dancer, mime, and my editorial team consultant, for her insights; Jerome Lipani, aka Hieronymous Blood, writer for his editorial and poetic inspirations; my daughter Degan, Kid cartoonist; my son Ariel, star fighter; and Oshin, our canine protector from Tibet.

For all my friends, compatriots, and fellow travelers, without whom History would have been short-changed. Poets extraordinaire, Ira Cohen, Richard Craven, Angus MacLise, Michael McClanathan, Gerard Malanga, Therese Thibet, Geraldine, aka Greenprey, flown at the beginning of the epoch, and Lionel Ziprin.

Bernard Shir-cliff, Will Hopkins, Neil Shakery, and James Wade for their professional support. Howard Eisenberg, attorney, who saved the day with a word.

Rita Fecher Dominguez, for space privileges in her studio, for the undaunted technological help of Jin Brennan, Bob Bailen, Rene Jagger, David Davis, and others.

Michael Hollingshead, chronicler of the inside scoop; author Joseph Gross, M.D., super shrink, for his enthusiastic aid; Martin Schneider, a first techno-media photographic artist and journalist and staunch humanist; Ken Wittenberg, photographer, my ally and confidant throughout. Henry Adams, bell and gong maker, filmmaker, and life-poet. Rose-marie Woodruff, documentarian and celestial dame of psychedelia; Jaakov Kohn, consultant; Micky Ruskin, impresario and host to the arts; Jason McWhorter, graphic seer; Charles Guliano, inside-track journalist; Charles Mingus, Jr., eagle-eyed observer and multimedia artist; Ruth Mandell, dancer, my fateful and fruitful connection to publishing; and Joseph Strand, artist, inventor, and fulcrum of energy; Judith Malina and Julian Beck, founders of the Living Theatre.

Sterling McIlhany, Edward Benguait, Dr. Jean Houston, R. E. L. Masters, Emmett Grogan, and my esteemed employers, the School of Visual Arts. My parents, Irving and Evelyn Snyder; Aldo Tambellini, my oldest colleague in the electro-media arts; Richard Davis, photographer; and Elsa Morse, video artist.

For the contributions and inspirations of Pierre Alien, Larry Barnes, Karen K. C., Jeff Day, Steve Ditlea, Kathy Dumas, Joy Fowler, Bruce Bacon, Debbie Friedman, Dino Frisone, Iris Lord, Bob Reyes, Frank Zimmerman; and to my photographic mentors, Diane Arbus, my friend who quietly illuminated the inner sanctum of the illusion, Man Ray, Moholy-Nagy, Edward S. Curtis, Horst P. Horst, Joseph Karsh, Cecil Beaton, and W. Eugene Smith, who revealed his compassionate vision with a sublime sense of purpose. Thomas Jefferson, United States President, who said something important about the importance of our having a revolution every ten years; and to the many others that I shared many "spaces" with.

Photographic credits: to Benno Friedman, photographic artist, with whom I shared much of the Sixties; Dan McCoy for his super aerials of Woodstock that showed the legions.